TCM

FORBIDDEN COCKTAILS

LIBATIONS INSPIRED BY THE WORLD
OF PRE-CODE HOLLYWOOD

ANDRÉ DARLINGTON

FOREWORD BY MARK A. VIEIRA

RUNNING PRESS
PHILADELPHIA

Running Press
Hachette Book Group
1290 Avenue of the Americas
New York, NY 10104
www.runningpress.com
@Running_Press

First Edition: May 2024

Published by Running Press, an imprint of Hachette
Book Group, Inc. The Running Press name and logo are
trademarks of Hachette Book Group, Inc.

The Hachette Speakers Bureau provides a wide
range of authors for speaking events. To find out
more, go to www.hachettespeakersbureau.com or
email HachetteSpeakers@hbgusa.com.

Running Press books may be purchased in bulk for
business, educational, or promotional use. For more
information, please contact your local bookseller or the
Hachette Book Group Special Markets Department at
Special.Markets@hbgusa.com.

The publisher is not responsible for websites
(or their content) that are not owned by the publisher.

Print book cover and interior design by
Amanda Richmond.
Photo styling by Kelsi Windmiller.

Film photo credits: Pages 19, 63, 178, 201, 218, 219,
220 (Everett Collection). All other photos courtesy
of Turner Classic Movies.

Library of Congress Control Number: 2023030669

ISBNs: 978-0-7624-8520-8 (hardcover),
978-0-7624-8521-5 (ebook)

Printed in China

APS

10 9 8 7 6 5 4 3 2 1

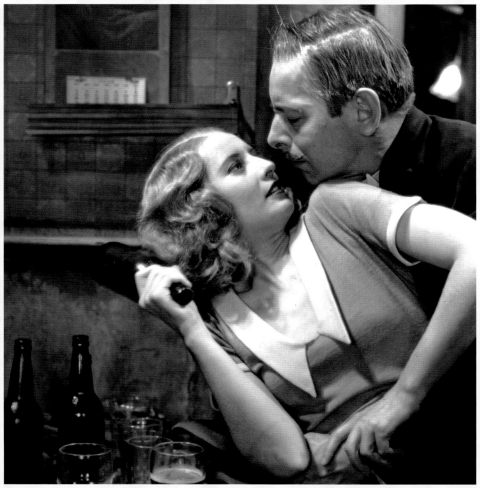

FOREWORD

MARK A. VIEIRA

Cocktails were the essential ingredients of pre-code cinema. Like sex and violence, cocktails were both forbidden and ubiquitous. They were forbidden by Prohibition and ubiquitous because people wanted them. Witness the "pint of ale and a pint of champagne" Robert Montgomery orders at an Art Deco bar in *Strangers May Kiss*, the "Paradise Cocktail" a bartender deftly mixes in *One Way Passage*, and the martinis William Powell shakes to a two-step in *The Thin Man*. What would pre-code be without demon drink? Alcohol was more than essential to the era. It was the elixir of life.

Even when pre-code films posed as morality tales, immoral behavior sold tickets, so drink in hand, these films glorified the sins they punished. In *Dance, Fools, Dance*, well-bred William Bakewell is ruined by a bootlegging career. In *The Public Enemy*, slum kid James Cagney steals alcohol barrels from a warehouse, the first step to ill-gotten affluence. In *Call Her Savage*, Clara Bow's rampages are

preceded—or followed—by drunkenness. Hollywood made it clear that the slide to hell was lubricated with liquor.

Amid all the dancing, drinking, and debauchery, no one—then or now—stopped to ask the obvious question: Why vilify Will Hays, Jason Joy, and Joseph Breen for being the enforcers of the Production Code? They had been hired to do a job. Why did filmmakers fight them so hard when their bosses had authorized them to do exactly what they did? The studios were, in a sense, in bed with the enemy, the reviled "censors." Out of necessity, the two sides forged a relationship. They fought and made up. Both sides compromised. But more often than not, the filmmakers prevailed. Pre-code films had a brazen, provocative energy that resonates ninety years later.

After viewing pre-code movies, many assume that the 1930s was an unbridled decade. In fact, it was a conservative time, constricted by economic depression and repressed by Victorian values.

"Community standards" prevailed over Hollywood creativity; thus, few people saw these films as we see them now, complete and uncut. They were often edited by state censor boards, local censors, and even by theater owners. Audiences in the "dry" state of Kansas, for instance, rarely saw an on-screen cocktail consumed; most of the drinking scenes were snipped before the film arrived at the theater. This left plenty of celluloid on the Kansas censors' floor; drinking was a pre-code constant. Drink drove stories and provided plot points. It sometimes drove characters to the brink of destruction, but more often, pre-code films handled drinking with a comic touch. In *Gold Diggers of 1933*, flirtatious Fay Fortune (played by Ginger Rogers, a real-life teetotaler) uses champagne to maintain her health, asserting with a smile, "My doctor recommends it." By late 1933, most of the country was smiling and sipping, too.

During the first three years of the Great Depression and the frightening first quarter of 1933, Hollywood's goal was to entertain the audience. The code's concern was not to stimulate that audience. Despite these contradictory objectives, the film industry survived this dark period. Movies provided an escape for the weary American, who may have been short of cash but could justify a quarter for a big-screen romance. By comparison, entering a speakeasy and ordering a cocktail would have been difficult (especially for the rural population), and a little more expensive; a basic cocktail started at twenty-five cents and ranged to fifty cents.

Thanks to this book, you need not choose between drink and entertainment. André Darlington has created fifty cocktail recipes to pair perfectly with his movie selections, fifty of the most intoxicating titles from the short-lived but prolific pre-code era. From *Morocco* to *Midnight Mary*, from *Safe in Hell* to *Scarface*, let this book be your guide. Pick up your swizzle stick and stir up the excitement Hollywood created between 1930 and '34.

Start the evening with cocktails, like Gaston in *Trouble in Paradise*. Rattle your shaker in time with Nick in *The Thin Man*. Take a swig from your flask like Lil in *Red-Headed Woman*. Stock up on the gin, the absinthe, the bitters, and the soda. Raise a glass to the frivolity of these films, but remember: although sin is the most important element in a pre-code cocktail, you can enjoy it responsibly.

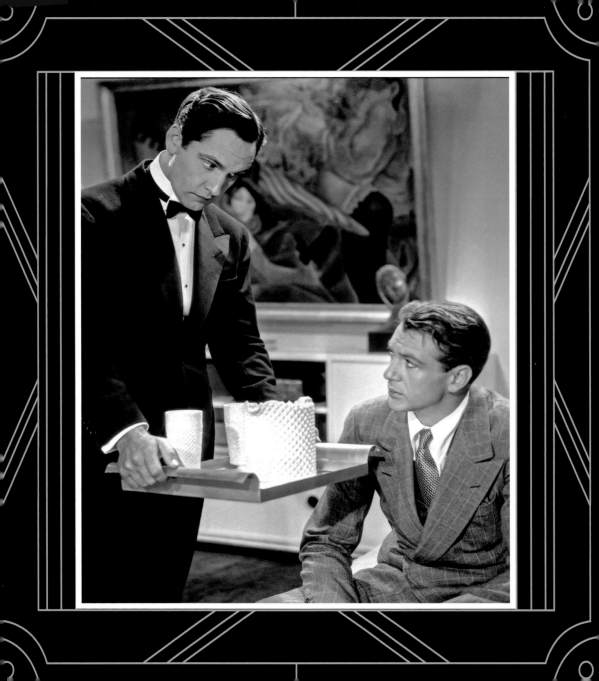

INTRODUCTION

ON THE
SILVER TRAY

The book you now hold in your hands features fifty movies from the "pre-code" era, defined as the four-year span when the film industry had a production code, but the studios chose to ignore it. The films of this era are untamed and suggestive, as if we are seeing American culture of a bygone time unvarnished. Compared to Hollywood films of the so-called Golden Era, pre-code movies are like forbidden fruit—especially when spiked with that harbinger of mischief, the cocktail.

◀ Fredric March offers Gary Cooper liquid refreshment.

Pre-code films are set against a complicated backdrop: from March 1930 when the Production Code was adopted, to July 1934, when the code was reconstituted; from Herbert Hoover and Prohibition to Franklin Roosevelt and legal liquor. The landmark pictures that bookend this period are *The Divorcee* and *The Thin Man*. Luckily for us, because the films overlap with the end of Prohibition, we get to see Prohibition-era cocktail culture as well as Hollywood at its most brazen. For more on the significance of pre-code cinema, see the "Pre-Code Explored" section that follows. For the complete picture readers are also encouraged to refer to another book in the TCM library, *Forbidden Hollywood*.

Let's turn our attention to the cocktails because there are important things to note. First, while pre-code films overlap with the final years of Prohibition, what we see on-screen up to the full repeal in December 1933 is surprisingly similar to what we see after. This is because Prohibition helped determine film settings; it is no accident there are so many border-crossings, yachts, speakeasies, and foreign cities in these films. It is not merely a display of upper-class mobility (although

it is that, too); characters in Europe, Asia, South America, and the Caribbean could be shown drinking. Second, while cocktails are sometimes employed to support plot or to reveal character, much of pre-code imbibing is "smart" drinking: cocktails are being presented as fashionable. This was specifically addressed by the code and technically forbidden.

There is a certain conceit in creating cocktails inspired by 1930s films because we know, more or less, what drinks were popular at the time. Ninety years later, they are still popular. Drinks like the French 75 and the martini show up in the historical record and on-screen. These are noted in the headnotes when they appear. I have also listed some of my favorite historical cocktails of the era on page 234.

The mixed drinks I have created for this book are inspired by some of the most enjoyable and fascinating pre-code movies. The recipes employ period ingredients in formulations that pay homage to characters, locations, and scenarios in the films. Think of these cocktails as lost cousins that could have been consumed at the time. They are what we imagine are in the chalices offered on silver trays to eager

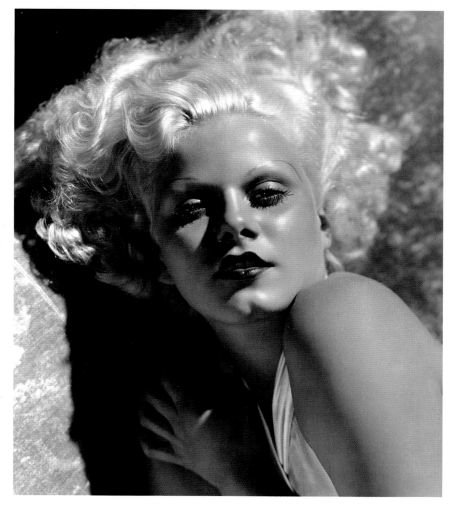

Platinum blonde Jean Harlow became a defining actress of pre-code Hollywood.

recipients. Of course, this also means the ingredients featured in this book can make other 1930s-era cocktails, a journey I hope you will continue alongside more exploration of pre-code cinema.

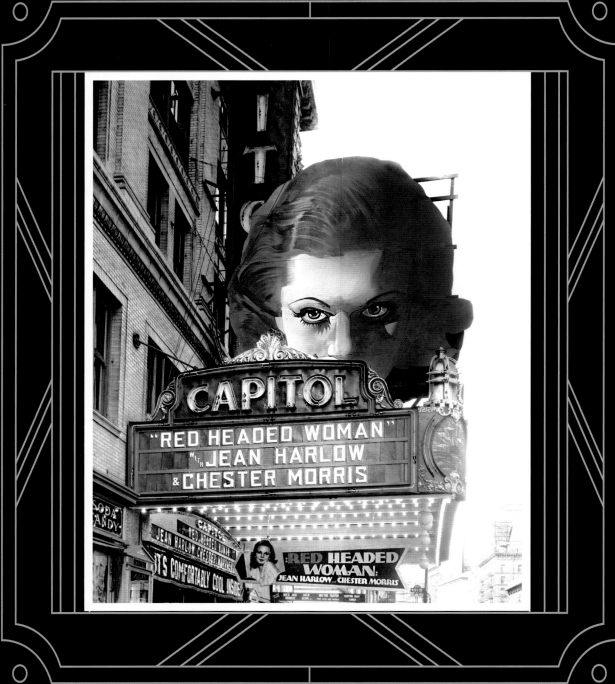

PRE-CODE EXPLORED

Hollywood, at first insulated from the Depression that had gripped the nation after the stock market crash of 1929, had its own crisis. Studios were losing money and were in political danger. Regional censor boards, goaded by local governments, were deleting "objectionable" scenes from films. Worse, the industry was being threatened with censorship by religious and political reformers, all of whom had the ear of Congress. Alcohol had been outlawed in 1920, so it was not unthinkable that Congress could create a national censor board and take away Hollywood's freedom to express itself.

◀ Harlow is unrepentant in *Red-Headed Woman*.

In 1922, Hollywood responded to these threats by creating a trade protection organization, the Motion Picture Producers and Distributors Association (MPPDA), and appointing a watchdog named Will Hays. However, there were no significant changes, and the newly introduced "talking pictures" in 1928 included racy dialogue and suggestive scenes. By 1929, Hays was so embattled that he recruited Catholic priests and scholars to collaborate with studio heads on a workable "code" of guidelines for film content.

In March 1930, the eight major studios signed the Motion Picture Production Code. This would ensure "clean pictures" and keep the bluenoses at bay. It should have worked—but the country was sliding into a Depression. As the box office plummeted, studios largely ignored the agreement and turned to sex, violence, and political themes to keep audiences' attention. No one took the code seriously, and Hollywood was making adult movies that could be seen by anyone.

Viewers who think all "old movies" are discreet and well-mannered look at pre-code as an alternate universe. How can what is happening on-screen be happening—back then, now, or at all? By 1932 Americans were asking the same question. Will Hays and the MPPDA were falling down on the job if they could allow "immoral" pictures. Hays, in turn, chastised his Hollywood officers. The Studio Relations Committee (SRC) was the agency empowered to approve screenplays and finished films—in essence applying the 1930 code. The SRC was overseen by Jason Joy, a reasonable censor who thought potentially offensive elements in a film could be adjusted or softened rather than simply chopped out. He believed in the integrity of the story. Not surprisingly, the studios took advantage of Joy's good nature and made increasingly transgressive films.

Pre-code films were not made in a vacuum. They reflect the times in which they were made. For the first few years of the Depression, President Herbert Hoover repeated the catchphrase, "Prosperity is just around the corner." Americans did not want hollow catchphrases; they wanted stability. In 1932, voters elected Franklin D. Roosevelt. The New Deal reforms of his tenure brought stability to America, and in early 1933 his administration ended Prohibition.

Meanwhile, Hollywood was growing more brazen, leading Catholic groups to

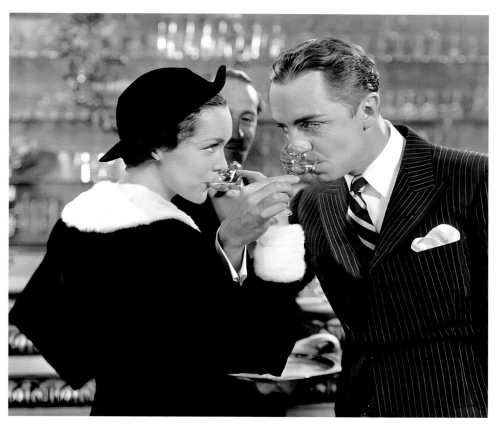

A post-Prohibition, pre-code scene from *The Thin Man*.

form a National Legion of Decency, naming wicked films and exhorting church-goers to avoid them. The motion picture industry was not immune to consumer reform—a Catholic boycott in spring 1934 cost Hollywood tens of thousands of dollars. The industry had no choice but to comply. In July 1934, the major studios signed a reconstituted code. This one had "teeth," as its militant administrator, Joseph Breen, proudly declared, and was duly enforced until 1968. Thus ended four years of cinematic impunity.

Fortunately, nearly a century later films of the "pre-code" era survive as a rollicking, endlessly entertaining view of the world of the early 1930s for new generations to reevaluate and enjoy. Cheers to that!

SINFUL SIPS AND DEMON DRINKS

COCKTAILS INSPIRED BY PRE-CODE HOLLYWOOD

THE
DIVORCEE

*A*ctress Norma Shearer heralded a new era of women's stories in movies with her portrayal of a confident young wife named Jerry. Upon learning that her husband, Ted (Chester Morris), has cheated on her, Jerry explores her own sexuality with Ted's best friend, Don (Robert Montgomery). Naturally, while Ted claims his dalliance did not "mean a thing," he is outraged at her indiscretion. The two divorce, and Jerry transforms into a party girl while Ted drowns his sorrows in drink.

Startlingly, this is all the plot one needs in order to know that in *The Divorcee* (1930) the female lead is portrayed not only as self-supporting and having an extramarital affair but also as having a healthy sexual appetite. Director Robert Z. Leonard's film is that proverbial scratch of the needle across cinema history as all eyes turn to a sympathetic portrayal of a woman facing patriarchal hypocrisy. The occasion is monumental, as if Shearer announces

Norma Shearer emerges from the world of men with a cocktail.

in this role that a twentieth-century woman—with her right to vote and newfound economic independence—has finally arrived as an equal. And with her arrival, everything has changed; relationships on-screen become modern and many cinema characters who follow in Jerry's wake in the 1930s are characters who feel contemporary.

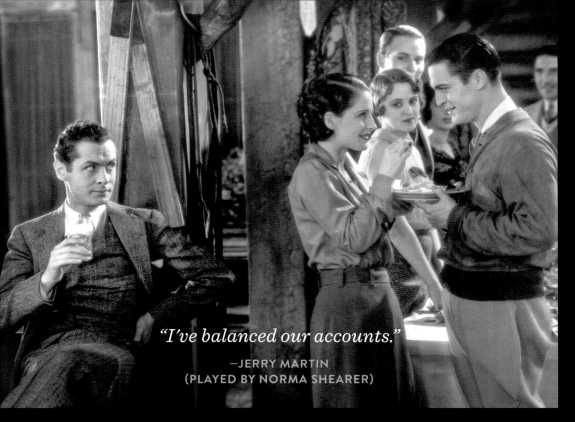

"I've balanced our accounts."

—JERRY MARTIN
(PLAYED BY NORMA SHEARER)

Lover Don (Robert Montgomery) eyes the married couple.

The *Divorcee* was nominated for Best Picture, and Shearer, wife of M-G-M production chief Irving Thalberg, won an Academy Award for her performance. She would go on to find the very edge for female roles in more films such as *A Free Soul* and *Strangers May Kiss* (page 46) while earning an additional four Best Actress nominations along the way.

Cocktails pervade *The Divorcee*, a gin-soaked drama if there ever was one. The film has an eye firmly trained on the New York City in-crowd and their habits. In this case, "in" turns out to be very boozy indeed, despite liquor's illegal status at the time. Raise a glass to the arrival of the modern American woman, resplendent in her long silk gowns and Art Deco settings.

BALANCED
ACCOUNT

"I've balanced our accounts."

—JERRY MARTIN
(NORMA SHEARER)

Before the "dry" version took the world by storm in the mid-twentieth century, martinis boasted more vermouth. Equal-parts martinis have come back into vogue and are a perfect way to balance the account in one's glass. Consider this an equal-parts martini with the inclusion of a Parisian interlude (Jerry looks for Ted three times in the City of Light). It is also an ideal cocktail for movie night because it scales up easily for a group and can be batched in advance.

1 ounce London Dry gin
1 ounce dry vermouth
1 ounce Lillet Blanc
2 dashes orange bitters
Lemon peel, for garnish

Stir gin, dry vermouth, Lillet Blanc, and bitters with ice and strain into a cocktail glass. Garnish with a lemon peel.

◀ A marriage of equals.

HELL'S ANGELS

Actress Jean Harlow's big break was Howard Hughes's sprawling aerial film *Hell's Angels* (1930). As party girl Helen, she displays all the guilt-free sexuality that would become her signature; she was the hottest new thing to arrive on the screen that year.

Begun as a silent film, *Hell's Angels* was shut down when the "talkie" revolution swept Hollywood in 1928. Hughes then reshot the technically advanced project. Censors were not thrilled that the new sound technology allowed audiences to hear actors say "goddamn it," "son of a bitch," and "for Christ's sake." Aside from its frank depictions of both war and sexuality, the film was praised for its masterly flight scenes and today is hailed as one of the great aerial movies of all time.

Harlow's debut was explosive. She famously asks, "Would you be shocked if I put on something more comfortable?" The line is funny but also key to understanding what made Harlow so provocative. With

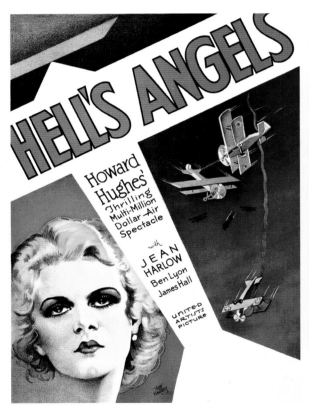

Harlow's hair would distract any aerialist.

other pre-code women, sex serves an ulterior motive: career, status, equality, and survival. With happy-go-lucky Harlow, sex is solely for fun and pleasure. She is both

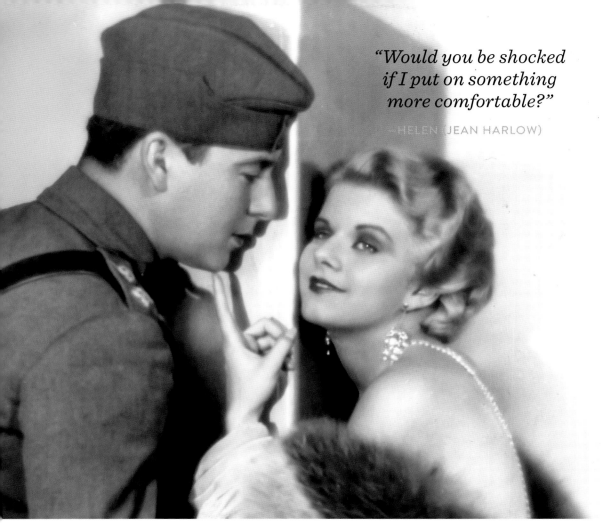

Harlow in something more comfortable.

revelation and revolution. Admittedly, when Harlow's blonde locks first grace the screen, her acting could use some work. Most of her fans were too fascinated by her appearance to care about her acting. She had a unique look; as she began to lighten her hair, she was dubbed "the Platinum Blonde." A few films later, in 1932's *Red-Headed Woman* (page 88), Harlow learned to act.

PLATINUM
BLONDE

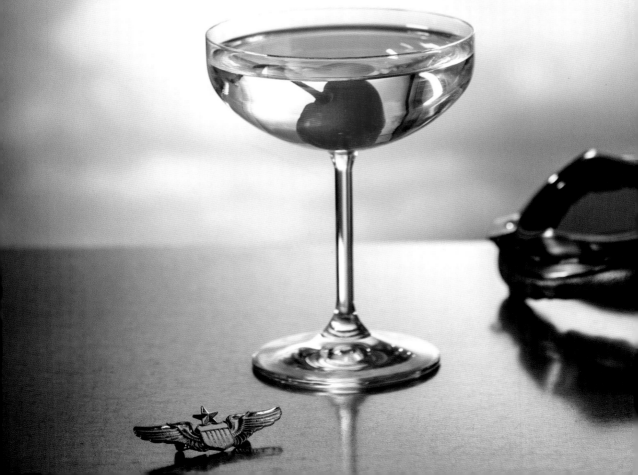

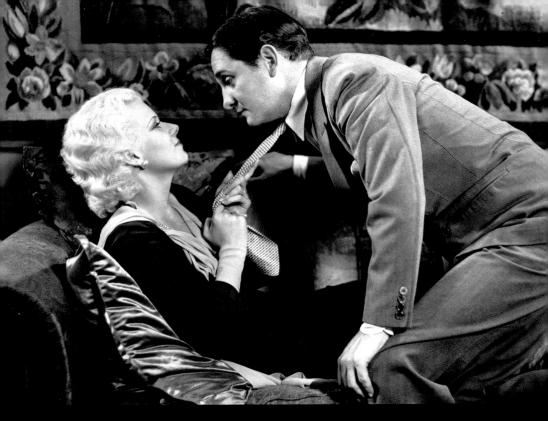

Jean Harlow and Robert Williams.

Harlow purportedly had a favorite drink, a kind of rum martini. It was equal parts rum and sweet vermouth with a dash of orange bitters, and the combination is named after her. Taking a cue from the actress's personal mix, this is a made-for-movie version. The cocktail has visual appeal to burn and is a delight with all kinds of foods.

2 ounces white rum
1 ounce dry vermouth

Stir rum, dry vermouth, and elderflower liqueur with ice. Strain into a cocktail glass and garnish with

ANYBODY'S WOMAN

Directed by Dorothy Arzner, the first female member of the Directors Guild of America, *Anybody's Woman* (1930) follows lawyer Neil Dunlop (Clive Brook) as he accidentally marries his burlesque dancer neighbor Pansy Gray (Ruth Chatterton) while on a bender. At least they already know each other; Dunlop represented Gray in court for indecency. Let's conclude Pansy is a bit short on feather boas and more of a stripper. Either way, there is plenty of lounging in gauzy nightgowns with a shapely leg slung over the arm of a chair, which is how Dunlop spied Pansy through a window in the first place.

What could be another poor-harlot-meets-rich-man plot à la *Pretty Woman*, instead gets the Depression-era treatment with a heavy dose of class consciousness and recognition of a woman's limited opportunities in 1930. Pansy is disillusioned with her marriage prospects,

her career prospects, and modern life in general; suicide is mentioned as an option and sometimes seems to be just a scene away. Arzner's multilayered take on a familiar romantic setup offers a lot of social commentary before the predictable denouement: low-class Pansy proves herself to be, despite appearances, the best option for comfortably middle-class Dunlop.

> *"I've made up my mind I'm never going to get that lit again."*
>
> —PANSY GRAY (RUTH CHATTERTON)

Like so many early "talkies," *Anybody's Woman* can be stilted, and its pacing prevents the plot from achieving a comedic clip, yet it is always lifted along by a sharp script and relatable acting. Ruth Chatterton's ferocious performance is typically gutsy (see also *Female* and *Dodsworth*); she was both an early aviator and a successful novelist.

Halfway through the film, a butler brings cocktails in small glasses sporting gold rims. Likewise, fortify yourself with this complex nip.

Paul Lukas and Ruth Chatterton. ▶

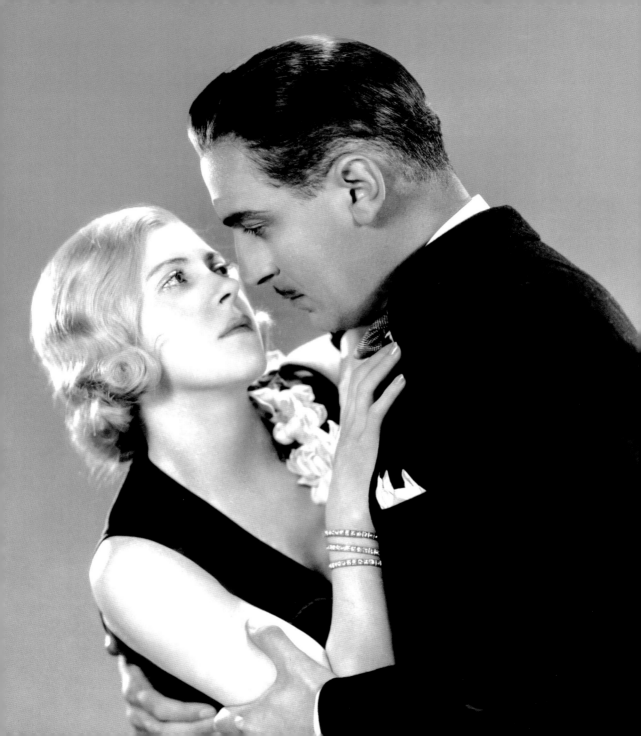

THE
BETTER
WIFE

◄ Ruth Chatterton was also a pilot and a novelist.

Anybody's Woman *was based on a short story by Gouverneur Morris entitled "The Better Wife." Here, the better wife fills a Nick & Nora glass (see "Glassware" page 233) neatly with just a bit more flavor and pizzazz than other wives. Astute imbibers will notice that the mix is a martini variation, but one with enriching elements.*

1½ ounces London Dry gin

1½ ounces dry vermouth

1 bar spoon Luxardo maraschino liqueur

1 dash orange bitters

1 dash Angostura bitters

Stir gin, dry vermouth, maraschino liqueur, and bitters with ice. Strain into a Nick & Nora or a cocktail glass.

Dorothy Arzner was the first woman member of the Directors Guild of America and the first woman to direct a sound film.

MOROCCO

Sultry and world-weary singer Amy Jolly (Marlene Dietrich) arrives in Mogador, Morocco, from Paris to perform at Lo Tinto at the same time as the Foreign Legion marches into town. Among the troops is handsome legionnaire Tom Brown (Gary Cooper), to whom Jolly finds herself attracted despite his womanizing. Meanwhile, a wealthy suitor (Adolphe Menjou) pursues her. This setup, however, does not convey director Josef von Sternberg's ability to tell a story with light, shadow, sound, silence, and subtle glances.

The film that made Marlene Dietrich a star, *Morocco* (1930), also garnered her only Academy Award nomination. It was a jaw-dropping first encounter. This is one of the first movies in which a leading lady kisses another woman. Perhaps even more startling to audiences at the time, the actress appears for her cabaret number in a men's top hat and tailcoat. This is Dietrich in all her pansexual, gender-bending glory. She is at once exotic and provocative, femme fatale and feminist.

It stands to reason that upheaval in societal roles would be reflected in clothing, and pre-code films are full of references to brassieres (as opposed to more constrictive Victorian corsets) and loaded with workaday calf-length dresses. But Dietrich catapults over the incremental fashion changes begun in the 1920s and announces herself as something else entirely: mannish and apparently bisexual.

> *"Every time a man has helped me, there has been a price. What's yours?"*
>
> —AMY JOLLY (MARLENE DIETRICH)

Remarkably, Dietrich's gender-bending performance in *Morocco* was largely accepted by her new American audience. It was when she showed up off-screen similarly adorned in a tux at the premiere of *The Sign of the Cross* (upstaging the film's cast) that the media went wild. The reaction was mixed. The public condemned her but also ordered so many women's versions of men's suits that tailor shops were forced to turn away business. Dietrich was forbidden. She was a sensation.

Marlene Dietrich in her signature top hat and tails. ▶

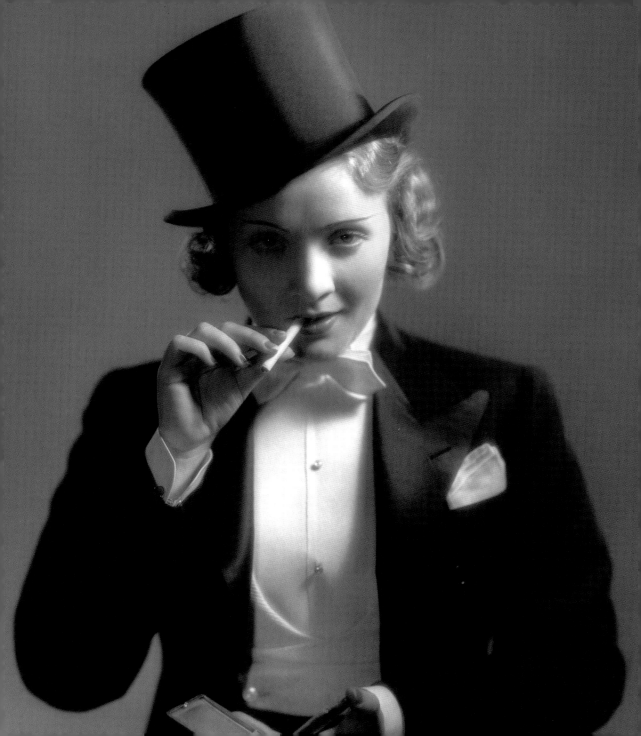

LEGIONNAIRE

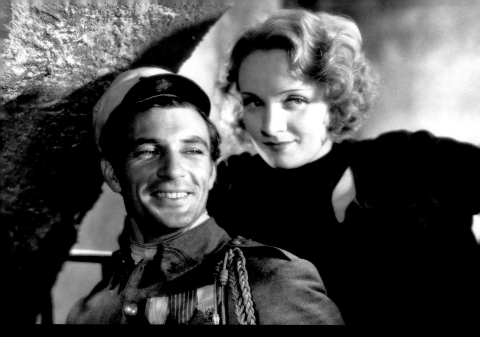

Amy Jolly (Marlene Dietrich) and her legionnaire (Gary Cooper).

Dubonnet is a bittersweet, fortified wine developed for the Foreign Legion as a way to make quinine palatable to malaria-prone troops. There are a few classic cocktails that call for it, and Dubonnet makes an interesting substitute for sweet vermouth in drinks such as Manhattans and negronis. This mix brightens the digestif with lemon and mint, ideal for a hot day under a North African sun.

ounce brandy
½ ounces Dubonnet
¼ ounce fresh lemon juice
½ ounce honey syrup
(see recipe below)
Mint leaf, for garnish

FOR THE HONEY SYRUP
cup water
½ cup honey

Shake brandy, Dubonnet, lemon juice, and honey syrup with ice. Strain into a cocktail glass and garnish with a mint leaf.

In a small saucepan over medium-high heat, heat water until just boiling and add honey. Remove from heat and stir until combined. Transfer to a sealable jar and let cool. Honey syrup will keep up to 2 weeks, sealed, in the refrigerator.

Dietrich and Cooper made for good publicity

LITTLE CAESAR

The first of an electrifying trio of gangster films—the others being *The Public Enemy* (page 50) and *Scarface* (page 84)—*Little Caesar* (1931) was a smash hit. Edward G. Robinson plays Caesar Enrico Bandello, a small-time gangster who moves to Chicago with his boyhood friend Joe (Douglas Fairbanks Jr.), who wants to be a dancer. That tidbit is the viewer's first hint that this is not simply the tale of a couple of crooks; the film's theme of unspoken and unrequited homosexual attraction is not subtle (although no writer or producer connected with the film would ever admit it). When Joe finds Broadway success in addition to dance partner Olga (Glenda Farrell), Caesar is consumed by jealousy. What unfolds is a story of crime, ambition, betrayal, and smoldering passion—all told in a sleazy, gritty style by director Mervyn LeRoy.

Audiences went wild for the movie, and for Robinson, who came to define the gangster on-screen with a volcanic-yet-taut screen presence and swarthy looks (not dissimilar to the infamous Al Capone's). Robinson is gigantic in the film, chewing up scenes and etching into memory his famous last line, which he delivers from the gutter while facing the camera: "Mother of mercy, is this the end of Rico?" It is hard to imagine another actor pulling off a performance that is impactful both for its intensity and sheer oddity.

The gangster film threatened traditional values because viewers were encouraged to identify with criminals. At the onset of the Depression, audiences were more than happy to do it; after all, who were businessmen but criminals who could afford lawyers, and what were the police but another gang?

Some of the movie's memorable action—that is, drinking and dancing—takes place at a nightclub named the Bronze Peacock. We can imagine what the spot might have served in early 1930s Chicago.

The birth of the gangster film. ▸

BRONZE PEACOCK

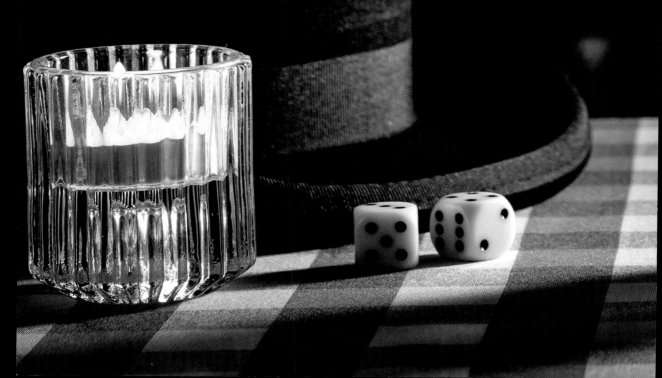

The Italian digestif Fernet-Branca famously appears in the Prohibition-era Hanky Panky cocktail. Created by bartender Ada Coleman at the Savoy Hotel, her mix added depth of flavor to what is essentially an early martini variation (gin and sweet vermouth). Here, Fernet builds on grenadine for a complex cocktail that could have been enjoyed at the Bronze Peacock.

1½ ounces bourbon whiskey
1½ ounces sweet vermouth
¼ ounce grenadine
1 bar spoon Fernet-Branca
Orange peel, for garnish

Stir whiskey, sweet vermouth, grenadine, and Fernet-Branca with ice and strain into a rocks glass with ice. Garnish with an orange peel.

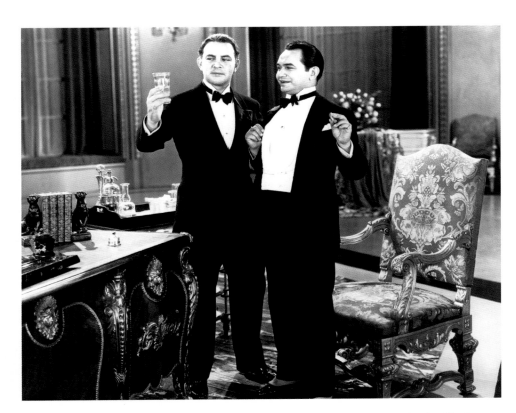

Raise a glass to . . . gangsters. ▲

A tale of jealousy. ▶

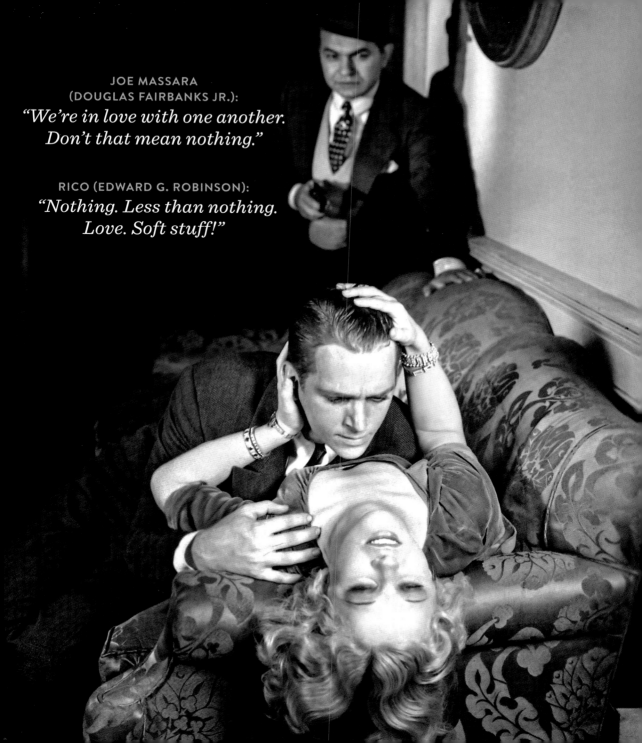

JOE MASSARA
(DOUGLAS FAIRBANKS JR.):
*"We're in love with one another.
Don't that mean nothing."*

RICO (EDWARD G. ROBINSON):
*"Nothing. Less than nothing.
Love. Soft stuff!"*

DRACULA

It is difficult now to comprehend the impact of Bela Lugosi's interpretation of Bram Stoker's vampire character. More than ninety years later, Dracula is an icon in popular imagination, and it is Lugosi in this film who made it so with his dazzling and terrifying performance. Lugosi is the archetype upon which the entire vampire-inspired universe is built.

Dracula exchanges fluids with everyone, but this is not even the most censorable aspect of the film. What gets tested in the pre-code horror genre are the foundations of civilization itself; Dracula raises questions about heaven, hell, and the nature of evil. Like *Frankenstein*, *Island of Lost Souls* (page 138), and other films of the era, major questions are posed: What is natural and unnatural? Is God dead? Who is the devil? Is there meaning in the universe or is there only void? Big issues. Ready the popcorn.

Dracula (1931), a horror story with no incidental music and almost no comedic element, was a big risk for a major studio.

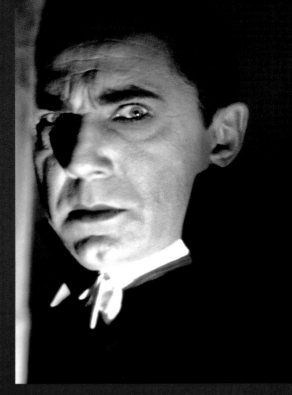

Bela Lugosi created Dracula
as we know the character today.

The bet paid off for Universal, however, and the film was both a box-office and critical success, lighting the way for further explorations of the dark. Lugosi, for his part, contributed one more creature for us to fear in the night.

The Studio Relations Committee—Hollywood's censorship board—did not object to the content of the film, but to an epilogue that was removed for fear it

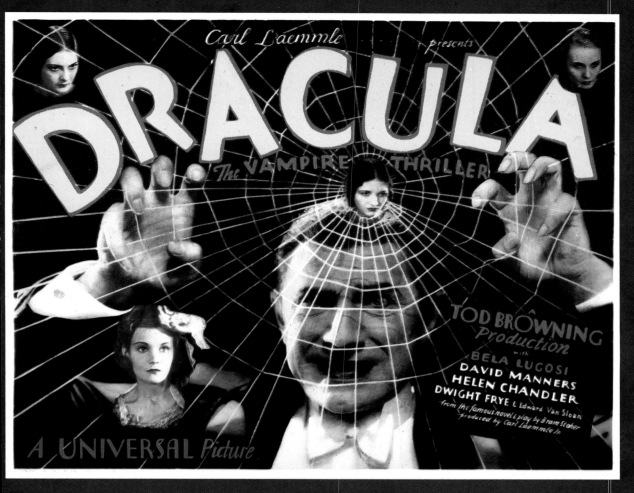

Carl Laemmle presents

DRACULA

The VAMPIRE THRILLER

A TOD BROWNING Production

with BELA LUGOSI DAVID MANNERS HELEN CHANDLER DWIGHT FRYE & Edward Van Sloan

from the famous novel & play by Bram Stoker produced by Carl Laemmle Jr.

A UNIVERSAL Picture

A horror film with little comedic element was a big risk for a studio.

encouraged belief in the paranormal. In the original version, actor Edward Van Sloan appears from behind a curtain and tells the audience: "When you get home tonight and the lights have been turned out and you are afraid to look behind the curtains— and you dread to see a face appear at the window—why, just pull yourself together and remember that after all, there *are* such things as vampires!"

COUNT DRAIQUIRI

RENFIELD (DWIGHT FRYE):
"Aren't you drinking?"

COUNT DRACULA (BELA LUGOSI):
"I never drink . . . wine."

This crimson cocktail would certainly interest Count Dracula. While today daiquiris are most often made with simple syrup, the use of grenadine adheres to old formulations—though not as old as Dracula himself. You will find this a helpful mix for steeling one's nerves against a frightening castle atmosphere in the Carpathian Mountains.

1½ ounces white rum
1 ounce fresh lime juice
½ ounce grenadine

Shake rum, lime juice, and grenadine with ice. Strain into a cocktail glass.

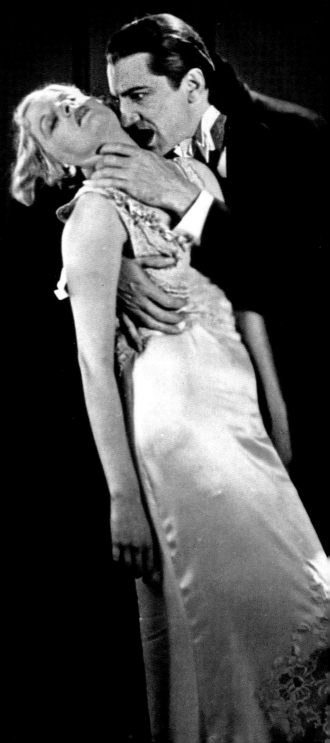

Lugosi taking a bite. ▶

THE EASIEST WAY

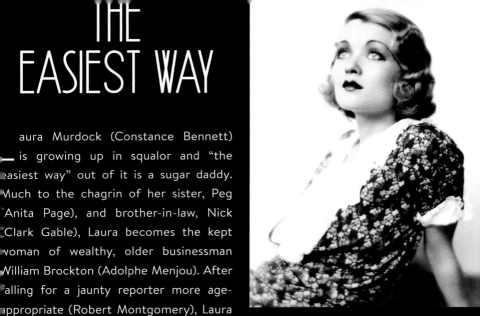

Who wouldn't use these looks to get ahead?

aura Murdock (Constance Bennett) is growing up in squalor and "the easiest way" out of it is a sugar daddy. Much to the chagrin of her sister, Peg (Anita Page), and brother-in-law, Nick (Clark Gable), Laura becomes the kept woman of wealthy, older businessman William Brockton (Adolphe Menjou). After falling for a jaunty reporter more age-appropriate (Robert Montgomery), Laura must choose between love and money. Spoiler: Because she starts two-timing her beaus, she gets neither.

Sleeping one's way into luxury (or just a meal) is a common pre-code theme, and Bennett spends plenty of time in her night-gown reminding viewers that she might as well use her looks to secure a better life. The film is smart and features enough great acting, Adrian gowns, and Art Deco sets to pull off what is essentially a long morality play. Plus, there is redemption for Laura in the end; despite losing both love and money, the film concludes with the uplifting return of the prodigal daughter to a family at Christmastime.

The Easiest Way (1931) was a hit and helped make Constance Bennett a talkie-era star, even though (or perhaps because) local censor boards cut copious amounts of footage from the film. Clark Gable, the future "King of Hollywood," makes one of

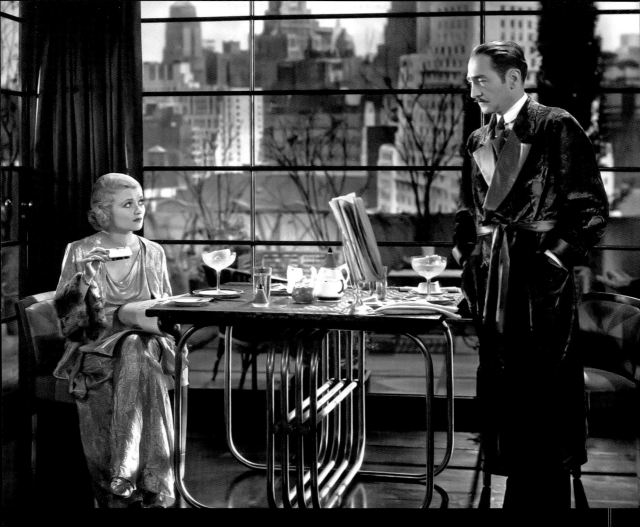

Cocktails with a sugar daddy.

his first on-screen appearances, notable
for its brutish masculinity. The film feels
modern not only for its subject but also
for characters who are all self-aware and
sensible about Laura's sexual arrange-
ments; her suitor does not flinch at the
idea that she's being kept, but simply
suggests she end the other relationship
before he offers marriage. The Great
Depression was no time for romantics,
making realists of both Hollywood char-
acters and audiences.

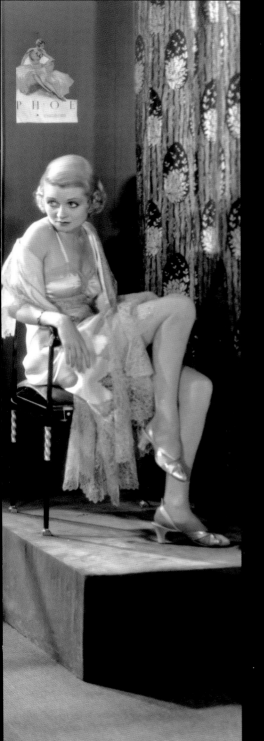

> *"Would you rather me have given you a ring? I made a payment on a lot instead!"*

—NICK FELIKI (CLARK GABLE)

Sometimes fate offers a choice between stability or romance. Luckily, with this greenish cocktail (representing money) garnished with a red cherry (love), you do not have to choose. Chartreuse is a French herbal liqueur that appears in several Prohibition-era (and earlier) drinks, such as the Last Word and Bijou. Here, it is joined by elderflower liqueur for a kiss of extra sweetness.

1 ounce London Dry gin
1 ounce green Chartreuse
½ ounce elderflower liqueur
½ ounce fresh lemon juice
Maraschino cherry,
for garnish

Shake gin, Chartreuse, elderflower liqueur, and lemon juice with ice. Strain into a cocktail glass and garnish with a cherry.

◀ Another day at work.

DANCE, FOOLS, DANCE

Strip down to your underwear and prepare to get wet because *Dance, Fools, Dance* (1931) opens with a yacht party during which guests jump overboard for a moonlight swim, bootleg cocktails in hand. The delight in this Jazz Age scene was short-lived because the joyous and carefree world of the 1920s comes to an end in the stock market tumble of 1929. This is the last party for these spoiled trust-funders; Bonnie Jordan (Joan Crawford) sees the stress of the crash take the life of her father and leave her and brother Rodney (William Bakewell) penniless. Bonnie would rather be independent and work than marry, and she becomes a newspaper reporter. Her brother, meanwhile, takes a less studious path and gets mixed up with bootleggers.

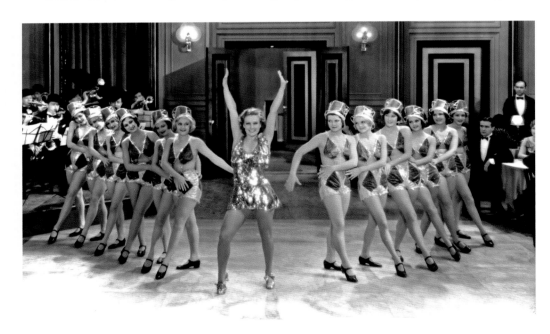

Joan Crawford leading a dance number.

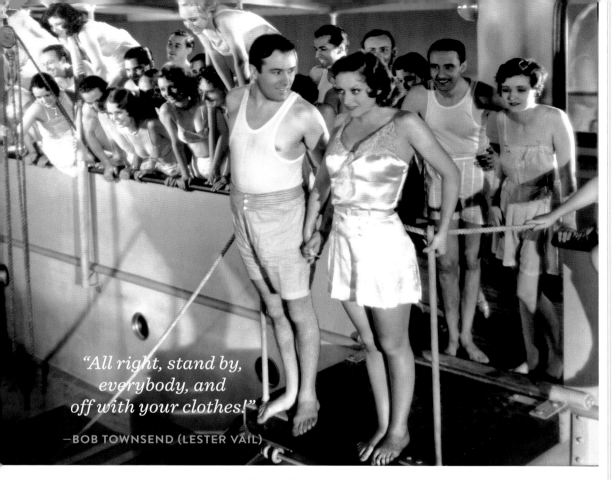

"All right, stand by, everybody, and off with your clothes!"

—BOB TOWNSEND (LESTER VAIL)

A delightful Jazz Age scene.

The setup is perfect for the drama that is to unfold: the cub reporter infiltrates her own sibling's gang. Elements of the gritty script are based on real-world events such as the Saint Valentine's Day Massacre and the 1930 murder of reporter Jake Lingle. Clark Gable plays the cruel but dynamic and irresistible gang boss.

This is the first of eight films Crawford and Gable would make together, Crawford having picked Gable personally to play opposite. In their moments on-screen together, the two exude the sensuality and wit that would make them one of the most successful acting pairs in Hollywood. Watch them strut, sparkle, and tussle.

LOVE on APPROVAL

As if a bootlegger main character and a mixed-company late-night swim was not scandalous enough, one of the film's themes is premarital sex. Or as Bonnie might describe the philosophy: try first and buy later. Both agree it should only ever be "love on approval." Note the cocktail consumed out of a teapot around minute eight. This is a drink for two that can be similarly served.

4 ounces brandy
2 ounces dry vermouth
1 ounce fresh lemon juice
½ ounce grenadine
2 lemon wheels, for garnish

Shake brandy, dry vermouth, lemon juice, and grenadine with ice. Strain into teacups (or a teapot), and garnish individual cups with a lemon wheel.

Crawford picked Gable for the film. ▶

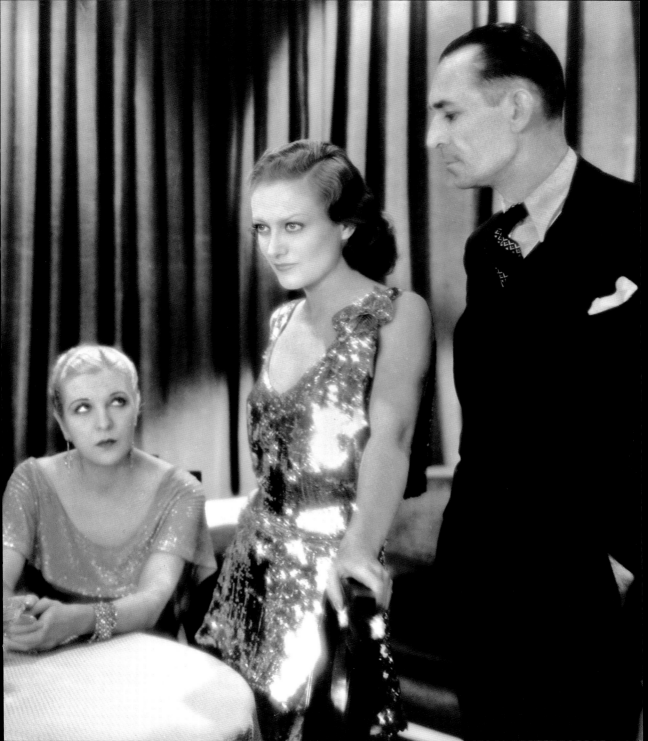

STRANGERS MAY KISS

A heady mix of feminism, premarital sex, and tragedy with a dose of steamy romance, *Strangers May Kiss* (1931) opens with a smooch so passionate it nearly crashes an airplane. Like *The Divorcee* (page 10), the film is based on an Ursula Parrott novel and stars Norma Shearer and Robert Montgomery. This time, Shearer plays Lisbeth, a secretary who decides to have premarital sex with a journalist, Alan (Neil Hamilton), even though he is not her fiancé. That would be Steve (Robert Montgomery), who is fine being cuckolded as long as she's happy and he's allowed his liquor.

While the younger generation accepts this arrangement, Lisbeth's aunt Celia (Irene Rich) is not so tolerant or modern; when she discovers her husband is unfaithful, she jumps from a window to her death. Shaken by the suicide, Alan and Lisbeth hightail it to Mexico, where looking into each other's eyes while donning sombreros does not cure Alan's wanderlust. Alan leaves, and a heartbroken Lisbeth heads to Europe to sleep her way across the continent while wearing increasingly revealing gowns.

In *The Divorcee* Shearer claims she is merely settling accounts, and both parties of the couple are miserable after their split, but *Strangers May Kiss* features Shearer unchained. Lisbeth's sex drive takes center stage, becoming both plot and problem, and we witness an ugly scene in which Alan denounces her for becoming the "promiscuous" object of continental gossip.

Admittedly, Alan's hypocrisy and Lisbeth's sudden guilt over her actions gets a bit thick, but fabulous sets and Adrian gowns make the movie look like an Art Deco painting. *Strangers May Kiss* is a sumptuous display of precisely what makes pre-code enjoyable: stars flouting conventions while on the move and looking marvelous. Drinks in hand, natch.

Neil Hamilton and Norma Shearer in Mexico. ▶

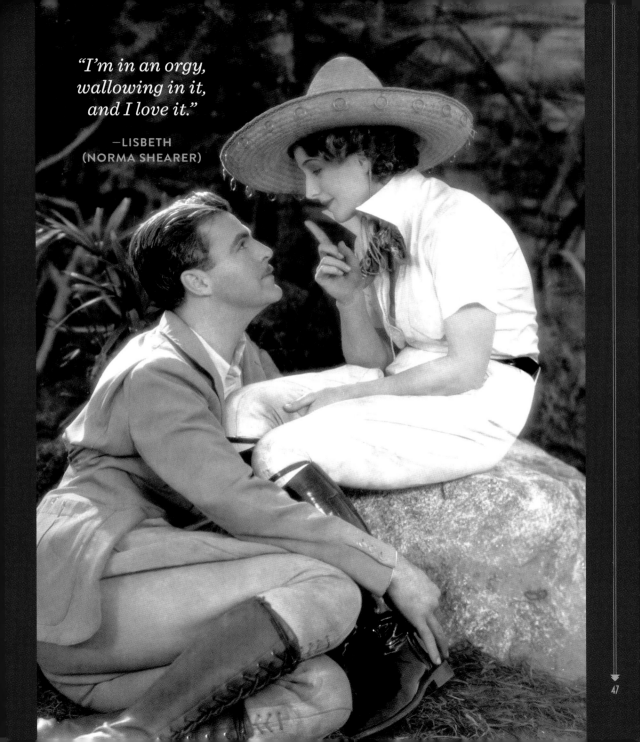

*"I'm in an orgy,
wallowing in it,
and I love it."*

—LISBETH
(NORMA SHEARER)

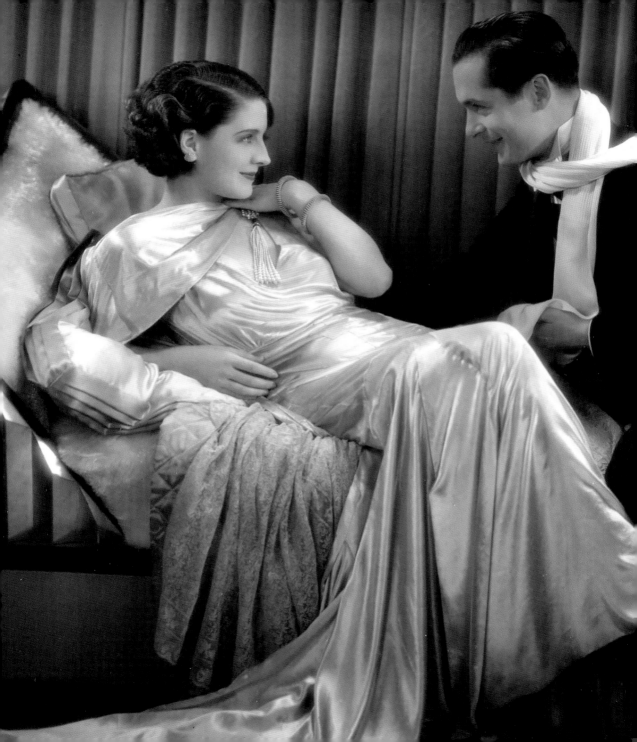

STRANGER'S
KISS

A trip to Mexico does not kindle sufficient romance between Alan and Lisbeth, but the sojourn makes for a great opportunity to try a south-of-the-border-inspired champagne cocktail. Champagne cocktails appear to be Lisbeth's favorite, and she notably orders one when she and Steve meet in Europe. She receives a large version with an ice cube (he orders a shandygaff, composed of beer and ginger ale). Toast to freewheeling travel in warm climes with this refresher.

1 ounce blanco tequila
½ ounce crème de cassis
¼ ounce fresh lime juice
1 ounce sparkling wine

Shake tequila, crème de cassis, and lime juice with ice. Strain into a cocktail glass with an ice cube and top with sparkling wine.

◀ Steve is happy as long he is allowed to drink and Lisbeth is happy.

THE PUBLIC ENEMY

B ursts of live machine-gun fire punctuate director William Wellman's *The Public Enemy* (1931), a vicious gangster biography in which bootlegger Tom Powers (James Cagney) luxuriates in his ill-gotten gains: bespoke suits, custom cars, and Jean Harlow for a moll. Playing a character devoid of feeling save lust and vengefulness, Cagney is the ultimate villain-turned-hero, who, unlike Robinson's Rico in *Little Caesar* (page 26), kills for the fun of it. If Rico is a fascinating creep audiences could not stop watching, Tom is a lovable sociopath with whom we identify: he was scarred by a brutal upbringing. Consequently driven to grab power, Tom is the American self-made everyman in a gangster bowler and overcoat.

Brutal and explosive, *The Public Enemy* shocked audiences. As the amoral Tom, James Cagney punches, kicks, and shoots his way to the top. There is the infamous scene in which he stuffs a grapefruit into the face of his girlfriend (Mae Clarke). In the next room, Edward Woods is in bed biting Joan Blondell's earlobe. There is also Tom's final moment in which he collapses and

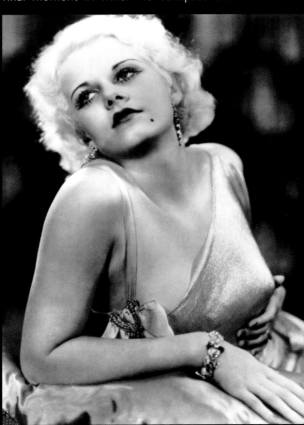

Harlow as the dream gangster girl.

James Cagney discovering if Mae Clarke likes grapefruit.

admits, "I ain't so tough." Despite romanticizing gangster life, or likely because of it, the film's reception was overwhelmingly positive; a New York theater showed the film 24 hours a day. Cagney portrays a sadistic criminal, but he has courageously pulled himself out of the urban underclass.

The censors gave a big thumbs-down to the amazing "hard-boiled" realism in the

film, passing it on the basis of its instructive value. The moviegoing public ensured that *The Public Enemy*'s box office outdid even *Little Caesar*. Real-life gangster Al Capone weighed in: "These gang pictures, that's terrible kids' stuff. They're doing nothing but harm the younger element of the country. I don't blame the censors for trying to bar them." *Rich*

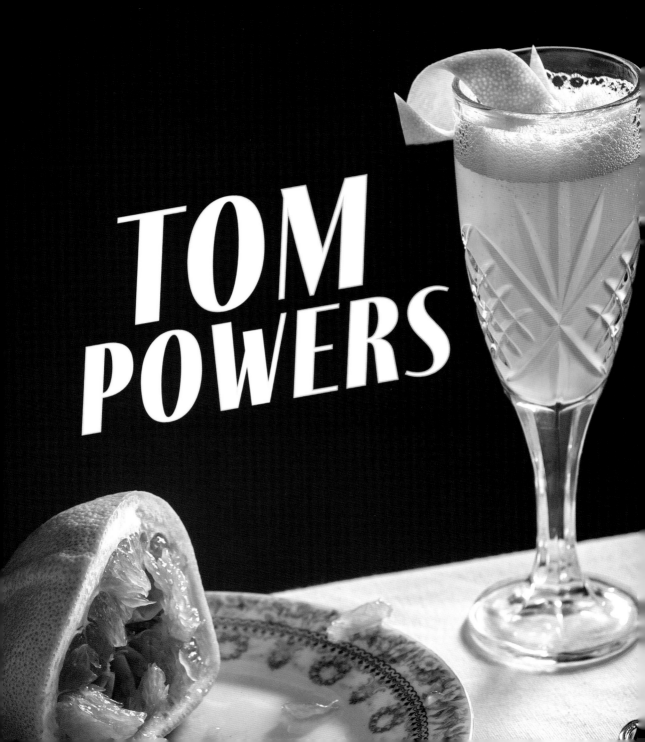

TOM
POWERS

1 ounce Irish whiskey

½ ounce fresh grapefruit juice

½ ounce Campari

¼ ounce Luxardo maraschino liqueur

1 ounce sparkling wine

Lemon peel, for garnis

NIGHT NURSE

Mortie (Ben Lyon) is the hero in *Night Nurse* (1931), saving the day in a twisted tale of poisoned children and scheming chauffeurs. This is surprising because Mortie is also a bootlegger. However, when the plot is killing children for financial gain by drug-addicted doctors and greedy socialites, a criminal hero may be the least alarming thing about this dark ride. Fasten your seat belts.

Nurse trainee Lora Hart (Barbara Stanwyck) is being shown the ropes at a hospital by Maloney (Joan Blondell) when she takes up work as a night nurse for Mrs. Ritchey (Charlotte Merriam). Ritchey retains violent chauffeur Nick (Clark Gable) for her dirty work—read sexual relations—but that isn't the half of it. When the housekeeper tips off Lora about a plot to starve Mrs. Ritchey's children in order to get their inheritance, it is time for the intrepid nurse to intervene.

Nurse Lora (Barbara Stanwyck) gets ready for work. ▶

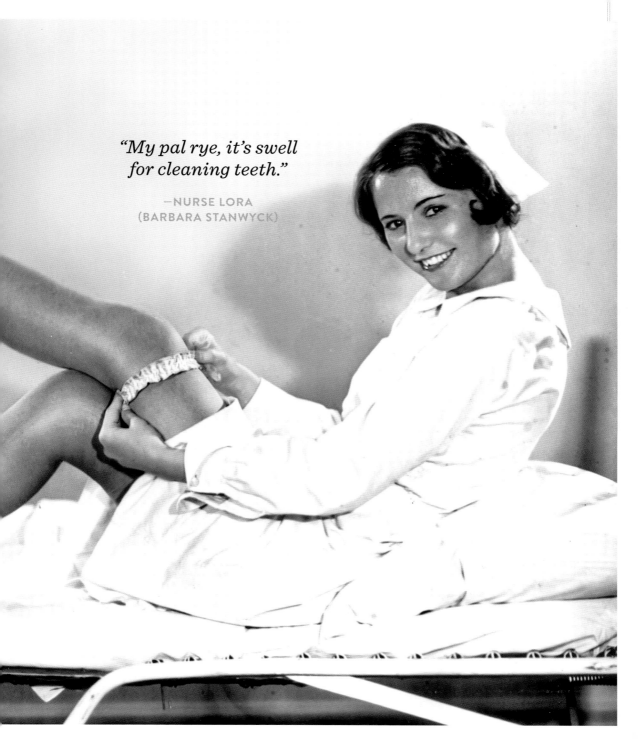

"My pal rye, it's swell for cleaning teeth."

—NURSE LORA
(BARBARA STANWYCK)

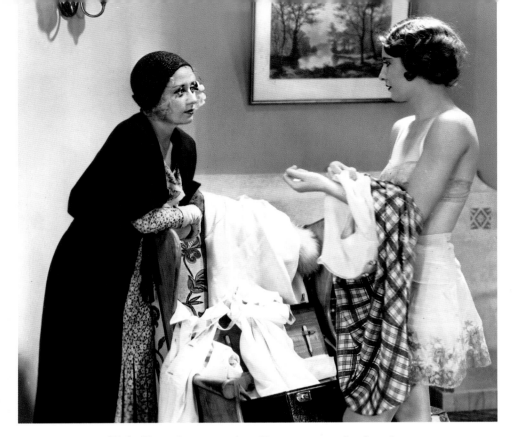

Night Nurse features an inordinate amount of undressing.

Fast-talking, hard-nosed Barbara Stanwyck is the star of this twisted drama, delivering an electric performance. In pre-code style, she and fellow nurse Joan Blondell spend an inordinate amount of time dressing and undressing from their nurse outfits. However, there is a lot more that is gratuitous in this film, including some knockout punches and plenty of sexual innuendo. It is a topsy-turvy tale where support staff and petty criminals are revealed to be the true moral compass of society as opposed to the upper class, which is revealed to be decadent and devious. This was a Depression-era attitude, and *Night Nurse* is the film to express it.

Note that while the recipe below is based on one of Barbara Stanwyck's lines, actress Joan Blondell inspired a cocktail named after her (see page 235) that is equal parts gin, dry vermouth, and Bénédictine, with a few drops of absinthe and a dash of Angostura bitters.

My Pal Rye

Plucky nurse Lora proves her drinking bona fides with a great line: "My pal rye, it's swell for cleaning teeth." As luck would have it, there is a rye-centric cocktail named Old Pal, which likely appeared in print for the first time in the late 1920s. In most recipes, the drink is a combination of rye, dry vermouth, and Campari. This riff takes things in a slightly softer direction.

1½ ounces rye whiskey
1 ounce Lillet Blanc
½ ounce Campari
1 dash orange bitters
Orange peel, for garnish

Stir whiskey, Lillet Blanc, Campari, and bitters with ice and strain into a cocktail glass. Garnish with an orange peel.

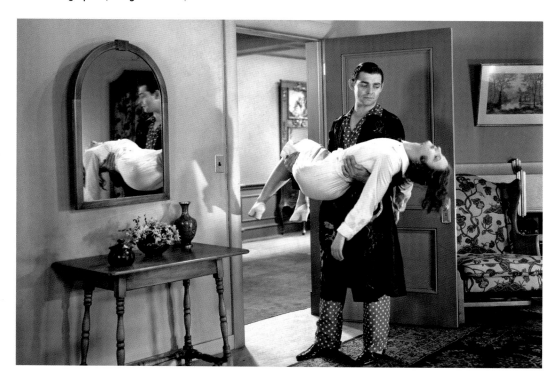

A chauffeur's job is never done.

THE LAST FLIGHT

Former flying ace Cary Lockwood (Richard Barthelmess) cannot hold a cocktail steady due to a war injury to his hands. It is a tough handicap to have in glittering Jazz Age Paris, where martinis, champagne cocktails, and sidecars flow fast. Lockwood's former tail gunner and buddy Shep (David Manners) is not much better off; he deveoped a nervous tic under his eye when their plane went down. Together, the two cope with their traumas by barhopping in the City of Light. Joining in their dissolution are pals Bill (John Mack Brown) and Francis (Elliot Nugent), American reporter Fink (Walter Byron), and the quirky, pretty Nikki (Helen Chandler).

Full of absurd wordplay and non sequiturs, the sharp script—along with director

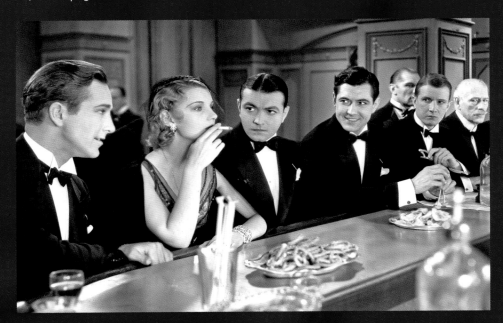

Living the good life at the bar.

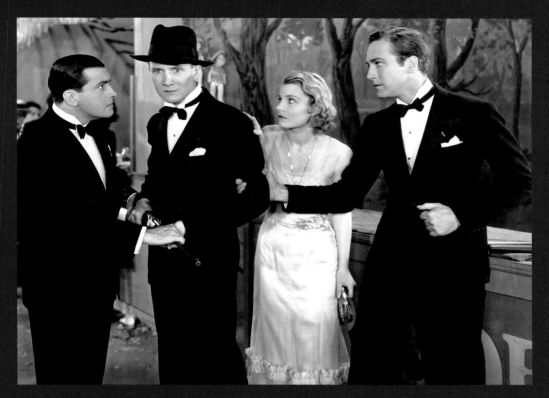

Put that gun down and have another drink.

William Dieterle's fast camerawork—captures the open-ended aimlessness of nights out with friends. The restless changes of scenery, the silly horseplay (the character Bill literally tackles a horse), and hours of drinking are seasoned with the frankness, razzing, and conflict that happens when hanging out with a small group for long periods of time. Of course, smoldering beneath all the superficial frivolity and lightheartedness is disillusionment. The film is a magnificent portrait of the damaged postwar "Lost Generation," emulating writers like Hemingway and F. Scott Fitzgerald; there's even a bullfight.

There is a fun morning cocktail scene when the gents order prairie oysters as a hangover cure, as well as an intimate moment when Shep and Nikki sip Picon Citrons, but it is their rounds of cocktails while out carousing that grab attention.

CARY LOCKWOOD
(RICHARD BARTHELMESS):
"How 'bout a cocktail?"

SHEP LAMBERT
(DAVID MANNERS):
*"Not a bad idea
at that."*

LAST FLIGHT

The Film's running gag about vanilla is the inspiration for this champagne cocktail. Whenever Nikki gets confused, she responds, "I'll take vanilla." Well, how 'bout it. Here is a vanilla-inflected champagne cocktail that will start off any night with friends right. The vanilla syrup employed here is a useful recipe to keep on hand for other drinks, especially around the holidays. Try it in an Old Fashioned, for instance.

¾ ounce London Dry gin
¼ ounce vanilla syrup
(recipe below)
5 ounces sparkling wine
Lemon peel, for garnish

FOR THE VANILLA SYRUP
1 cup water
1 cup granulated sugar
1 tablespoon vanilla extract

In a champagne flute, combine gin and vanilla syrup. Top with sparkling wine and garnish with a lemon peel.

In a small saucepan over medium-high heat, heat the water until boiling. Remove from the heat. Add the sugar and vanilla and stir until combined. Transfer to a sealable jar and let cool. Syrup will keep in the refrigerator for up to 2 weeks.

BAD GIRL

S ex pervades *Bad Girl* (1931). It is on everyone's mind, and everyone wants it. But as we all are warned in middle school, the consequences of even looking at someone of the opposite sex is pregnancy. In this case "spooning" until 4 a.m. finds working-class lovers Dorothy Haley (Sally Eilers) and Eddie Collins (James Dunn) expecting and married within weeks.

Shot on a small budget, *Bad Girl* was a huge hit and earned director Frank Borzage his second Best Director Academy Award. The film launched unknown actors Eilers and Dunn to stardom with its open-eyed portrayal of sexual relations in hard economic times. While the film's title leads one to believe the story will be salacious, what shines through is a heartfelt view of a couple's daily struggles. This is a sympathetic study of common problems in early married life.

There are some wonderful moments in *Bad Girl*, chief among them luminous shots of Coney Island, where Dorothy meets

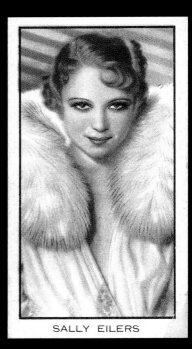

SALLY EILERS

Sally Eilers went on to a big career in the 1930s.

Eddie. These culminate in a first-person shot of one of the amusement park's roller coasters. Also notable is a staircase scene involving a drunk, a neighbor, a prostitute, and Limburger cheese. Then, to apply the cherry atop this pre-code sundae, watch for Dorothy in a negligee while her friend's eight-year-old son checks out the goods.

Dorothy (Sally Eilers) and Eddie (James Dunn) share a happy moment. ▶

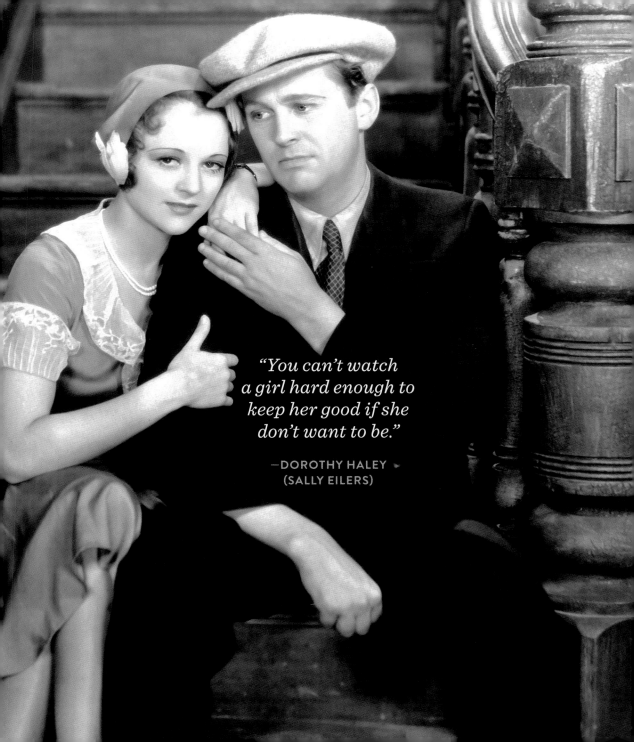

"You can't watch a girl hard enough to keep her good if she don't want to be."

—DOROTHY HALEY
(SALLY EILERS)

CONEY ISLAND ROLLER COASTER

Fun shots of Brooklyn's Coney Island open the film, paying particular attention to its roller coasters. America's first enclosed amusement park, Coney Island opened in 1895 and was connected by subway in 1920, which allowed the middle and lower classes access. Roller coasters also made their appearance in the 1920s, and the biggest of all was the Cyclone, built in 1927. This Coney Island–inspired cocktail is a blend of popular period ingredients, with the three cherries representing the popular roller coaster.

2 ounces white rum

¾ ounce orange juice

½ ounce raspberry syrup (recipe below)

1 bar spoon Luxardo maraschino liqueur

3 maraschino cherries, for garnish

FOR THE RASPBERRY SYRUP

1 cup water

1 cup sugar

1 cup fresh raspberries

Shake rum, orange juice, raspberry syrup, and maraschino liqueur with ice. Strain into a cocktail glass and garnish with cherries.

In a small saucepan, bring water to a boil. Remove from heat, add sugar, and stir to combine. Add raspberries, and mash thoroughly with a potato masher. Let mixture macerate 1 hour and strain into a sealable jar. Raspberry syrup will keep up to 2 weeks in the refrigerator.

SAFE IN HELL

The opening shot of *Safe in Hell* (1931) pans up Gilda Carlson's legs to her garters, a popular camera move in pre-code film. Next, we watch as our chain-smoking New Orleans hustler goes into a room to turn a trick, only to discover the guy waiting for her is ex-boyfriend Piet Van Saal (Ralf Harolde), who forced her into prostitution. What else can she do but hit him in the head with a bottle?

To escape, Gilda (Dorothy Mackaill) heads to a Caribbean island that has no extradition agreement with the United States. She is safe—in hell—with a party of other criminals seeking similar tropical asylum. When Van Saal shows up (he faked his own death), our heroine successfully kills him. She cannot sleep her way out of this jam with the island's jailer Mr. Bruno (Morgan Wallace) because she has promised to be faithful to her ex-boyfriend-turned-fiancé Carl Erickson (Donald Cook).

It will not come as a surprise that *Safe in Hell* was deemed "not for children" at the time of its release; its subject is a cash-strapped, homicidal hooker on an island of lascivious fugitives. The sordid plot is given wonderful atmospheric assistance by director William Wellman's back-lot re-creation of the oppressively hot and boring tropics. Everyone sweats in hell, and Wellman makes sure the audience feels each miserable, sticky drip.

"Sure this ain't the YMCA?"

—GILDA CARLSON
(DOROTHY MACKAILL)

Of special note in the film are a couple key 1930s Black actors. Harlem Renaissance songwriter and director Clarence Muse plays the hotel porter. Famed silent-era actress Nina Mae McKinney, known for her standout role in King Vidor's *Hallelujah*, plays Leonie, the cheerful, sexy concierge, and the film benefits from her rendition of the 1931 standard "When It's Sleepy Time Down South," which was co-written by Muse.

Not what they mean when they say "hit the bottle." ▸

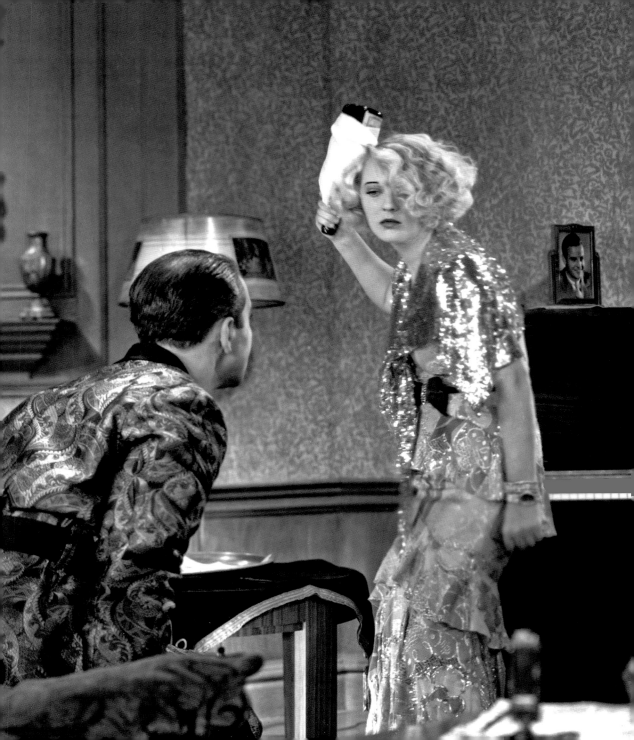

Gilda Carson enjoys a cocktail while on the phone.

LADY FROM NEW ORLEANS

Gilda needs a cocktail that is both a little bit New Orleans and a lot Caribbean. Enter this pineapple-inflected twist on a classic Nola drink, the Vieux Carré. Legendary bartender Walter Bergeron invented the Vieux Carré in the 1930s. This alluring gem is named after an alternative working title for the film.

1 ounce brandy

1 ounce sweet vermouth

¾ ounce pineapple juice

¼ ounce Bénédictine

1 dash Peychaud's bitters

Pineapple leaf, for garnish

Shake brandy, sweet vermouth, pineapple juice, Bénédictine, and bitters with ice. Strain into a rocks glass with ice and garnish with a pineapple leaf.

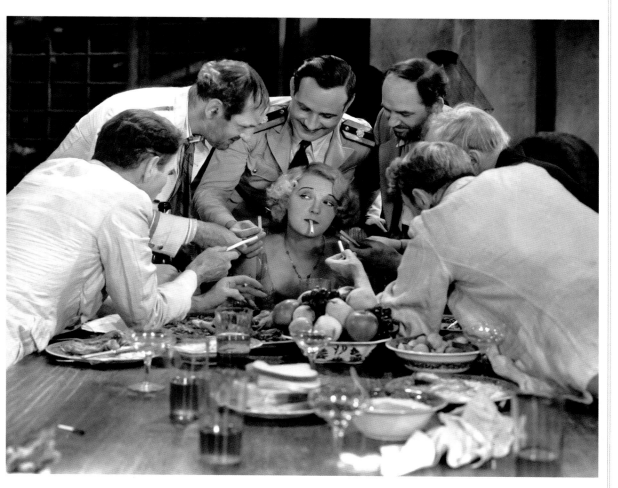

Maybe hell isn't so safe.

DR. JEKYLL AND MR. HYDE

Dr. Henry Jekyll (Fredric March) is thirsty—thirsty for his fiancée Muriel Carew (Rose Hobart), to be exact. In fact, it is possible to read the entire plot of director Rouben Mamoulian's innovative 1931 film as a study of sexual repression. The film is based on the short novel by Robert Louis Stevenson, but sculpts the story of addiction into a Freudian tale in which sexual desires lead to disaster. The story line is a reflection on the age in which the movie was made, a cipher for the obsessions and fast-changing mores of the 1930s.

From the outset, we are informed that Muriel's father, Brigadier General Sir Danvers Carew (Halliwell Hobbes), waited five years to marry her mother. Dr. Jekyll is having a hard time waiting eight months and is being tempted by siren Ivy Pearson, who is played by actress Miriam Hopkins in all her garter-legged glory. The setup prepares us for a generational clash between the Victorian model of delayed gratification and the Depression model of instant gratification. Many pre-code films frankly include premarital sex. This one takes another approach and shows what happens when it is forbidden. Smartly cast Fredric March won an Academy Award for his portrayal of a man frustrated in love—and ruined by sex.

DR. LANYON (HOLMES HERBERT):
"Perhaps you're forgetting, you're engaged to Muriel."

DR. JEKYLL (FREDRIC MARCH):
"Forgotten it? Can a man dying of thirst forget water? And do you know what would happen to that thirst if it were to be denied water?"

The message of the film is clear: sexual frustration leads to murder. ▶

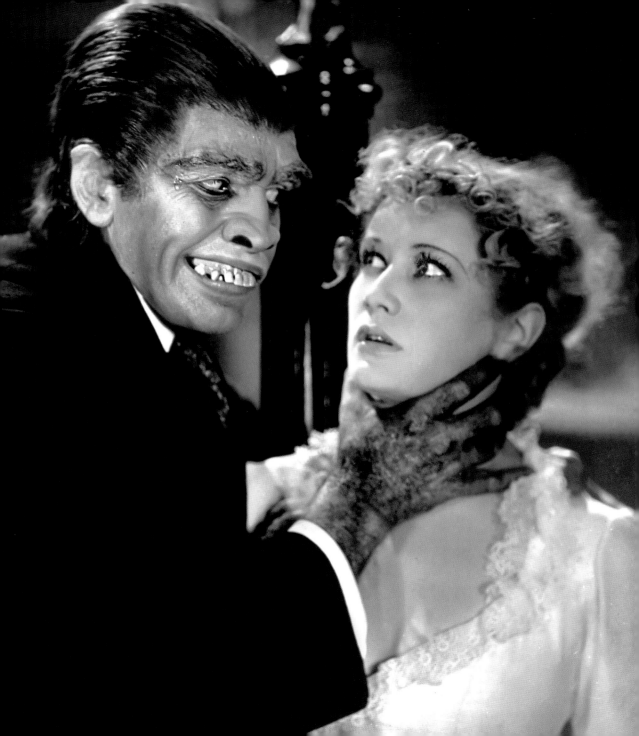

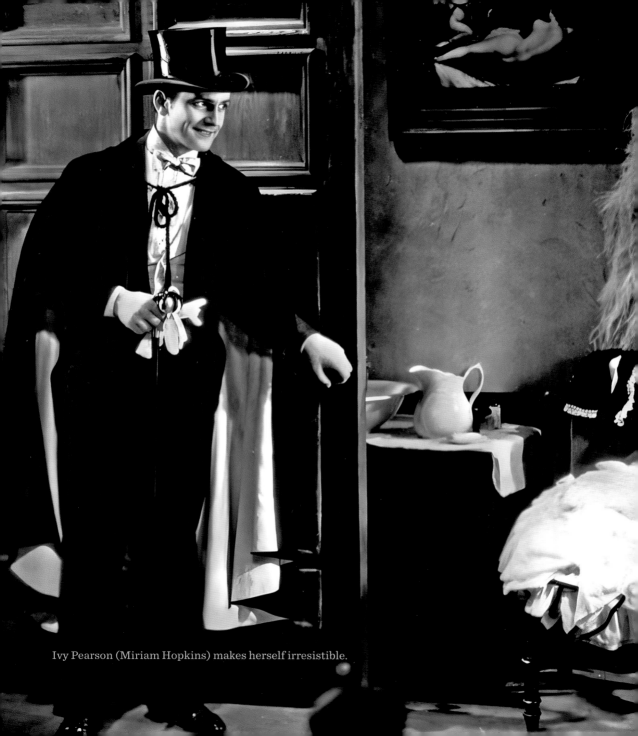

Ivy Pearson (Miriam Hopkins) makes herself irresistible.

The film's action centers around alchemy, a potion to be exact. Let's call it a cocktail. Jekyll consumes it the first time in the name of science. The second occasion is recreational; he is in despair because Muriel still refuses to marry him (read: have sex) without her father's consent. The concoction causes Jekyll to transform from his nobler self into an impulsive animal. This cocktail is similarly divided but do not worry; you do not have to stand in front of a mirror to watch its effects.

2 ounces applejack
1 ounce fresh lemon juice
½ ounce honey syrup
(see page 25)
¾ ounce red wine

Shake applejack, lemon juice, and honey syrup with ice and strain into a rocks glass with a large ice cube. Float the red wine on top of the drink by pouring it slowly over the back of a bar spoon.

Fredric March contemplates
his next drink. ▶

SHANGHAI EXPRESS

Marlene Dietrich is Shanghai Lily, a notorious courtesan making her way across China in the middle of a civil war in 1932's *Shanghai Express*. Her train and its passengers are taken hostage by Henry Chang (Warner Oland), a warlord who takes a fancy to Lily. Captain Harvey (Clive Brook), a brain surgeon who happens to be Lily's former lover, is aboard and on his way to an important surgery. Will Chang release them?

It does not take a brain surgeon to predict that our courtesan will be forced to make a choice between her ex-lover's safety and fidelity to him. She offers herself to Chang in order to save Harvey, but as luck would have it, fellow prostitute Hue Fei (Anna May Wong) is also on the train and stabs the warlord first. Finale: Doc realizes Lily is, in fact, faithful.

While the film's hooker-with-a-heart-of-gold plot might be as thin as a pre-code blouse, it is a sumptuous vehicle for Marlene Dietrich, who is once again directed by her discoverer and mentor Josef von Sternberg (see *Morocco* page 22 and *Blonde Venus* page 106). The costuming is extravagant, the camerawork glorious, and the hit film went on to be nominated for three Academy Awards, including Best Picture and Best Director; it won Lee Garmes the Academy Award for Best Cinematography.

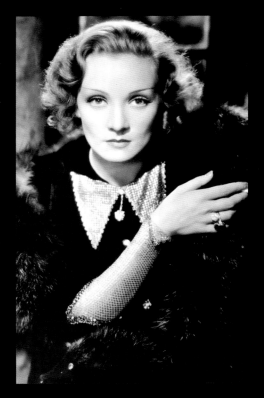

Traveling in style.

Hue Fei (Anna May Wong) sacrifices herself to save the day. ▶

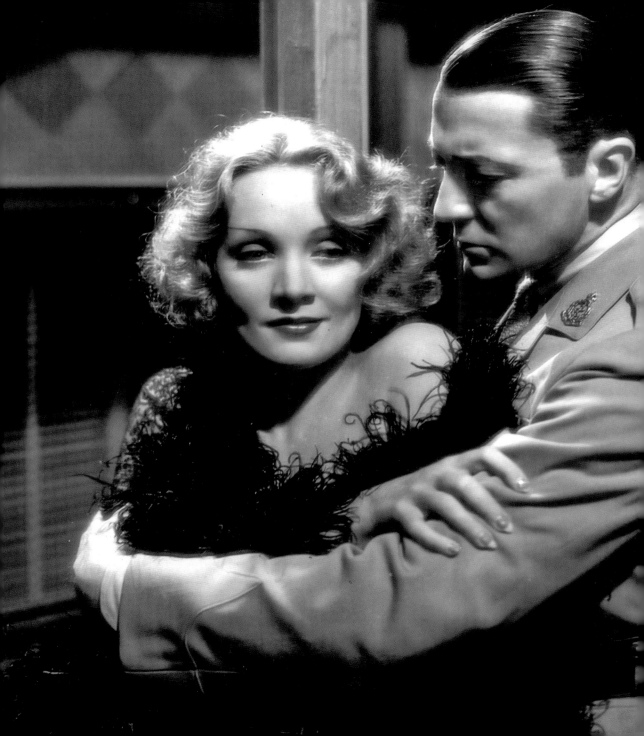

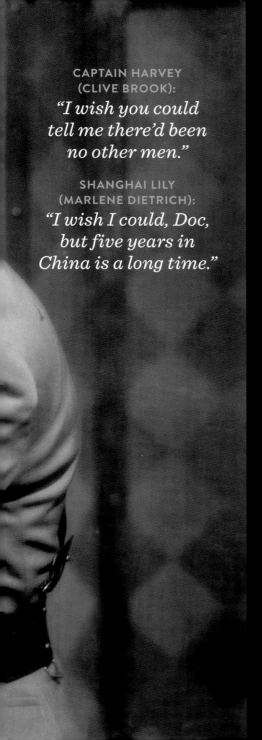

CAPTAIN HARVEY
(CLIVE BROOK):
"I wish you could tell me there'd been no other men."

SHANGHAI LILY
(MARLENE DIETRICH):
"I wish I could, Doc, but five years in China is a long time."

SHANGHAI LILY

What does a courtesan drink on a train traveling across China? This blend of rum, lemon, and mint is a good answer. It is a glamorous cocktail of mystery and complexity. The added touch of absinthe and vanilla offers a singular flavor combination that is not soon forgotten.

2 ounces white rum
1 ounce lemon juice
¼ ounce absinthe
¼ ounce crème de menthe
¼ ounce vanilla syrup (see page 61)

Shake rum, lemon juice, absinthe, crème de menthe, and vanilla syrup with ice and strain into a cocktail glass.

◀ The old flame with Doc Harvey is rekindled.

THIS IS THE NIGHT

Cary Grant plays a cuckold in his debut performance in *This Is the Night* (1932). Returning unexpectedly from the Summer Olympics, Grant's character Stephen discovers that his wife, Claire (Thelma Todd), is about to embark on a romantic vacation to Venice with her well-to-do lover Gerald (Roland Young).

To hide the scheme from Stephen, Gerald pretends he is taking his own wife, hiring out-of-work Germaine (Lili Damita) to act the part. The two couples sojourn in Italy together and, through various hijinks, Claire rekindles her passion for her husband while Gerald falls in love with his pretend wife.

Featuring a continental flare, musical numbers (Cary Grant can sing), and a running gag in which Claire's evening gown is ripped away by a car door, *This Is the Night* is a sophisticated and saucy comedy. Legend has it Grant hated this first big role; he

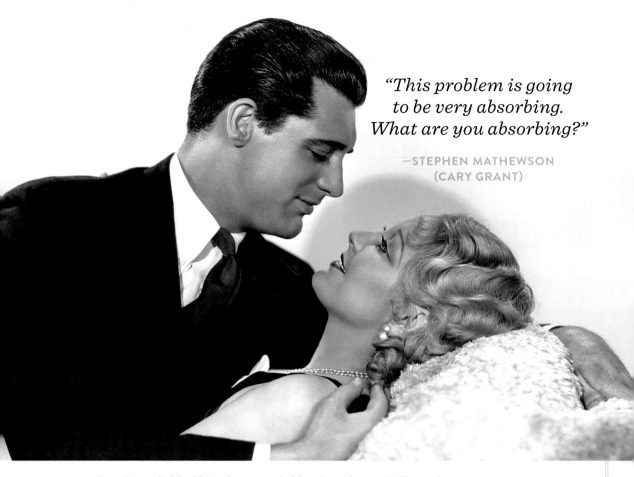

Cary Grant disliked his role as a cuckold and nearly quit Hollywood over it.

thought his character's easy acceptance of his wife's infidelity was not believable, and he nearly quit Hollywood over it. Luckily, with a little encouragement from friends and an ironclad contract with Paramount, Grant went on to make more pre-code classics (see *Blonde Venus* page 106 and *She Done Him Wrong* page 148) and became one of the great leading men of Hollywood history.

Although *This Is the Night* lost money, Paramount made many more sexy comedies with similar templates, such as *Trouble in Paradise* (page 122) and *Design for Living* (page 196). The studio realized the juxtaposition of European locales and loose morals were a winning match.

◀ Everyone finds love in the end.

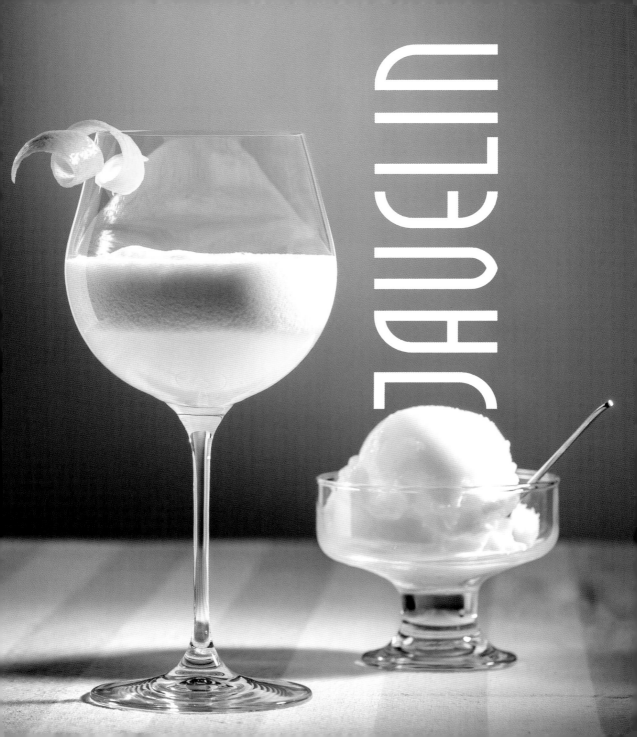

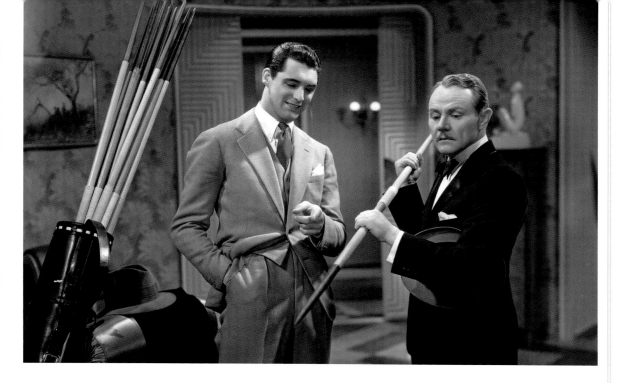

Cary Grant's character is an Olympic javelin-thrower, which is where this cocktail gets its name. The inspiration is Venice, and no trip to the city is complete without sampling its famous cocktails: the Bellini, the Aperol Spritz, and the Sgroppino, to name a few. Hailing from as early as the sixteenth century, the Sgroppino is named after sgropin, or the knots in one's stomach following a big meal. Thought to aid digestion, the drink has become one of the city's signatures. This version respects Stephen's preference for Scotch.

1 ounce blended Scotch whisky

3 ounces prosecco

½ ounce cream

2 scoops lemon sorbet

2 dashes orange bitters

Lemon peels, for garnish

Combine Scotch, prosecco, cream, sorbet, and bitters in a chilled bowl and stir without ice until frothy. Pour into wineglasses and garnish with lemon peel.

▲ Charles Ruggles plays with Cary Grant's javelin.

SCARFACE

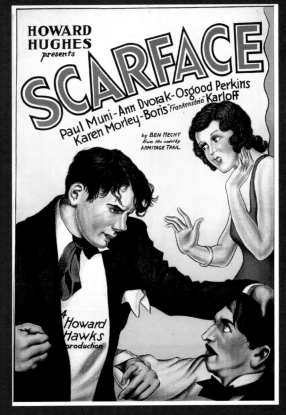

Scarface was the most violent
gangster film to date.

Set in Chicago and inspired by gang-
ster Al Capone, the Howard Hughes–
produced *Scarface* (1932) was one of the
most violent films of the era. What little
charm James Cagney's Tom Powers dis-
played in *The Public Enemy* (page 50) is
absent from actor Paul Muni's character,
Antonio Camonte. In fact, pathological
"Tony" seems to derive physical pleasure
from firing his tommy gun.

Drawing on the legend of the Borgias,
Ben Hecht's script gives his murderous
hero a case of unrequited incest. Tony
has a powerful fixation on his sexy sister,
Cesca (Ann Dvorak), and when he finds
her living with his best friend, Guino
(George Raft), Tony assumes the worst
and kills him. No one has time to tell
Tony that his sister and his friend have just
been married.

Scarface, directed by Howard Hawks,
was actress Ann Dvorak's big debut. She
would go on to make several films display-
ing her no-nonsense, urban-girl charisma
(see *Three on a Match*, page 118). As for
Paul Muni, he had another great film the
same year, the notable *I Am a Fugitive from
the Chain Gang*, and was nominated for an
Academy Award.

Scarface signaled the end of the gang-
ster genre. It went too far with its detailed
re-creations of real gangland murders. While
praised by critics, the cold and sinister film
was trimmed to several different versions
to appease the censors and was regarded as
too unpleasant by most audiences.

Paul Muni talks to a disheveled Ann Dvorak. ▶

"They'll be shooting each other like rabbits for control of the booze business!"

—BEN GUARINO
(C. HENRY GORDON)

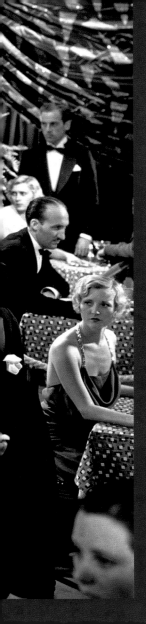

WARD

The film opens the morning after a big party thrown [in?] the First Ward, an area that in the 1930s included wh[at] is now Chicago's Loop. There is evidence cocktails we[re] named after city wards, such as the Ward 8, thought [to] have been created in Boston in 1898. A few decades lat[er,] Esquire magazine listed it as one of the best cocktails [in] 1934. The classic Boston mix is the loose inspiration [for] this creation, which pays homage to Chicago's (histor[ic]) First Ward.

2 ounces bourbon whiskey
½ ounce fresh lemon juice
½ ounce fresh orange juice
¼ ounce Luxardo maraschino liqueur
1 bar spoon absinthe
Lemon peel, for garnish

Shake whiskey, lemon juice, orange juice, maraschino liqueur, and absinthe with ice. Strain into a cocktail glass and garnish with a lemon peel.

◀ A night out with drinks.

RED-HEADED WOMAN

atten down the hatches. Here comes hurricane Harlow. *Red-Headed Woman* (1932) was originally scripted by F. Scott Fitzgerald and Marcel de Sano, but producer Irving Thalberg brought in writer Anita Loos (also see *Midnight Mary* page 176) to lighten the story's mood. The film stars platinum blonde Jean Harlow, who dyes her hair red in the film's opening scene while cackling, "So gentlemen prefer blondes, do they? Ha!"

Off we, and Harlow's clothes, go as gold digger Lillian "Lil" Andrews wrecks her boss Bill's (Chester Morris) marriage and then tries to force her way into high society by a bit of trickery with tycoon Charles Gaerste (Henry Stephenson). Through a private detective, Bill learns Lil is sleeping with not only Charles but also the

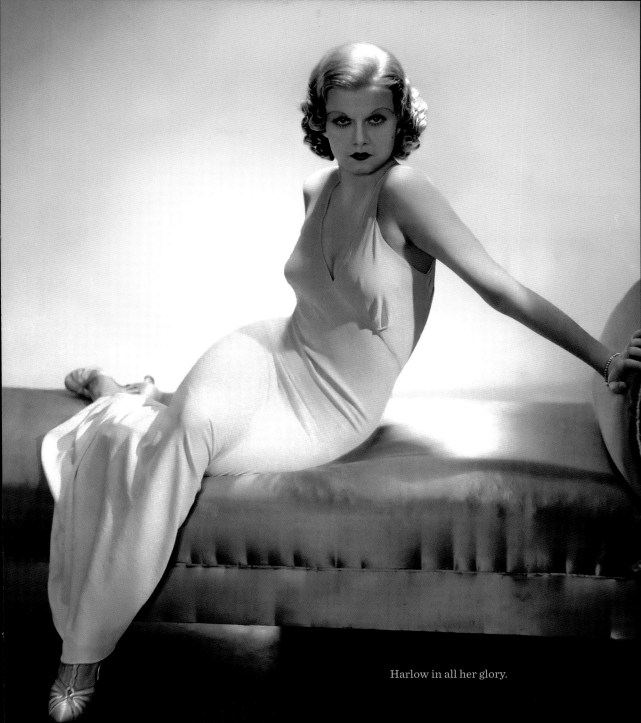

Harlow in all her glory.

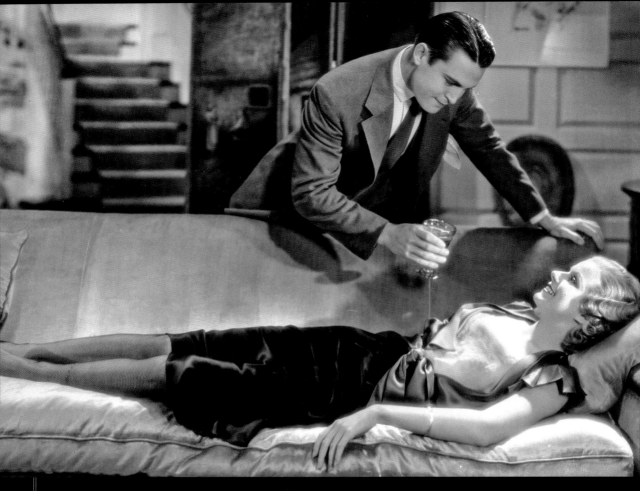

Bill offers Lil a refreshment.

handsome chauffeur (Charles Boyer), and he sensibly returns to his ex-wife. Lil shoots Bill for this bout of sanity, but he survives, and she moves on to an elderly Frenchman. Hurricane Harlow has passed.

Introduced to audiences in *Hell's Angels* (page 14), Harlow made *Red-Headed Woman* as her first film after her falling-out with Howard Hughes. It is a saga of naked ambition laying waste to social norms. Lil wants status, and she is going to get it by hitting below the belt and showing that it is not a man's world anymore. Audiences went wild for Lil, and Harlow earned recognition as both a comedienne and a star.

"You won't be long, will you, dear?"

"I'll be up at cocktail time."

LIL RED

Taking redhead Lil as inspiration, this crimson number is a seductive mix with a real kick. It is just the ticket for anyone who grew up on the wrong side of the tracks but who wants to play in the big leagues. There is plenty of alcohol for added chutzpah, along with a spicy finish.

1½ ounces London Dry gin
1 ounce sweet vermouth
¼ ounce Cointreau
2 dashes Peychaud's bitters
Orange peel, for garnish

Stir gin, sweet vermouth, Cointreau, and bitters with ice. Strain into a rocks glass with a large ice cube and garnish with an orange peel.

MILLION DOLLAR LEGS

Welcome to the imaginary country of Klopstokia, where the chief exports are goats and nuts. Hailed as one of the funniest movies ever made, the bizarro *Million Dollar Legs* (1932) is an anarchic cross between Looney Tunes and Monty Python. The story follows fast-talking traveling brush salesman Migg Tweeny (Jack Oakie) who, finding himself in Klopstokia, runs into Angela (Susan Fleming) on a street corner and instantly falls in love. Angela turns out to be the daughter of the president (W. C. Fields) of this obscure and debt-ridden country.

Hoping to woo Angela and win her father's approval, Migg conjures a plan to have his brush manufacturer sponsor a Klopstokian Olympic team. However, rebellious cabinet members plot to have femme fatale Mata Machree (Lyda Roberti) seduce members of the team and thwart the scheme.

Jack Oakie is surrounded. ▶

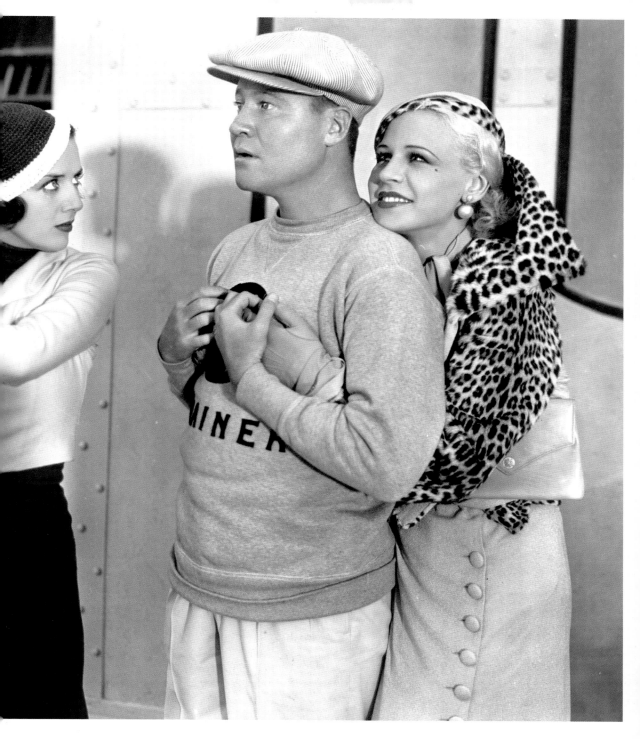

GEORGES
&
ANGELAS

Early in the film we learn that all men in Klopstokia are named George (except, for some reason, Angela's younger brother, Willie) and all women are named Angela. Since we are told all the residents are also either goats or nuts, try this cocktail, which is a perfect pairing for both. A goat cheese, such as chèvre, accompanied by walnuts, is an ideal match for this herbaceous and lemony mix.

1 ounce brandy
1½ ounces Riesling wine
¼ ounce fresh lemon juice
½ ounce honey syrup
(see page 25)
1 sprig fresh thyme, for
garnish

Shake brandy, Riesling, lemon juice, and honey syrup with ice. Strain into a cocktail glass and garnish with a thyme sprig.

W. C. Fields (right) contemplating his next lift.

> *"So, you're the woman no man could resist.*
> *You blondine, overstuffed cooch-dancer!"*

—ANGELA (SUSAN FLEMING)

An expensive leg.

Surreal and silly, *Million Dollar Legs* is a satire of Herbert Hoover's broken America, but also a daffy send-up chock-full of contemporary in-jokes meant for hip audiences. Plus, it is hard to miss the film's self-aware riff on reality by casting Polish actress Lyda Roberti pretending to be Swedish actress Greta Garbo by way of playing real-world spy, Mata Hari—herself a Dutch woman who pretended to be Malaysian. It is a lot of lunacy, and that is the point.

LOVE ME TONIGHT

Lauded as one of Hollywood's first musical masterpieces, what *Love Me Tonight* (1932) lacks in choreographed song-and-dance numbers, it makes up for in seamless intertwining of music and narrative. Directed by Rouben Mamoulian and featuring songs by Richard Rodgers and Lorenz Hart, the film stars Maurice Chevalier and Jeanette MacDonald. The pair made four musicals together, this being the only one not directed by Ernst Lubitsch (see page 122) .

Charming Parisian tailor Maurice Courtelin (Chevalier) is owed money by aristocrat Viscount Gilbert de Varèze (Charles Ruggles), so he decides to visit Gilbert's castle in order to collect. There he encounters Varèze's uncle, Duke d'Artelines (C. Aubrey Smith), d'Artelines's sex-hungry niece (Myrna Loy), and the beautiful Princess Jeanette (MacDonald). Fearful his uncle will be angered by his debt, Gilbert introduces the tailor as his friend Baron Courtelin, whereupon Jeanette promptly falls in love with him. When later (but not much) caught in a state of undress with the princess, Maurice must reveal his identity by sewing her clothes back together. Will she love the poor tailor despite his lack of station?

PRINCESS JEANETTE (JEANETTE MACDONALD):

"Count, I'm going to bed."

COUNT DE SAVIGNAC (CHARLES BUTTERWORTH):

"I just came up to join you!"

The film features a number of cheeky and surprising moments, chief among them the editing work for the song "Isn't It Romantic?" during which the tune is passed through a montage to characters in various locales. The result feels less like the often-static musicals of the era and more like the first-ever music video. With Charlie Ruggles, C. Aubrey Smith, and Charles Butterworth on hand, there are great ensemble moments, but Myrna Loy—who would go on to become famous in

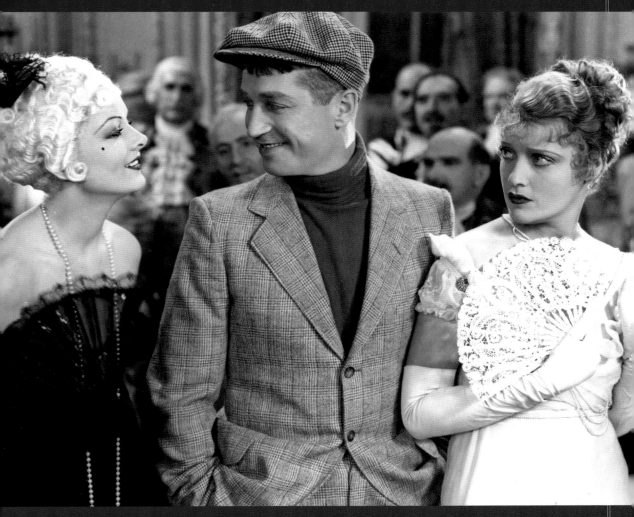

Myrna Loy (left) steals her scenes.

films such as *The Thin Man* (see page 222)—positively gobbles up her scenes. When asked if she ever thinks about anything other than men, she answers, "Oh, yes! Schoolboys." Regrettably, the version of *Love Me Tonight* that has been passed down to us is missing a few censored minutes of her reprise of the song "Mimi." The section was removed because the lyrics were too risqué.

FLAT ON MY FLUTE

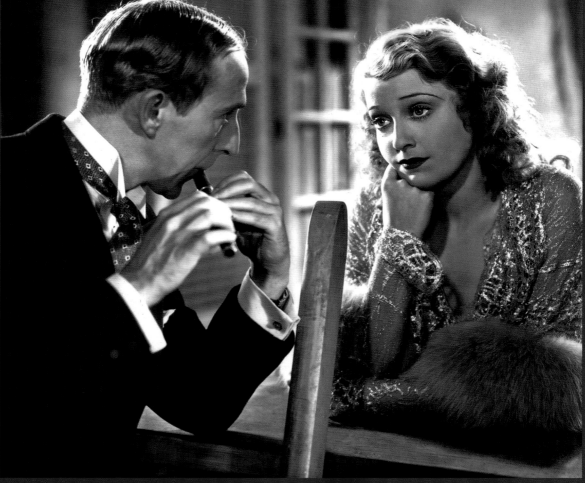

Charles Butterworth as an amorous flutist.

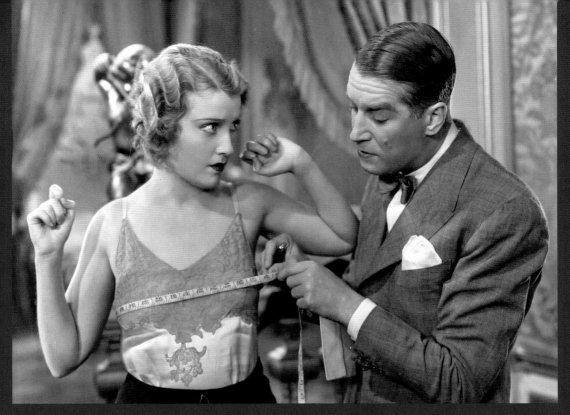

Maurice Chevalier measuring Jeanette MacDonald.

After climbing a ladder outside Princess Jeanette's bedroom, would-be suitor Count de Savignac falls into the garden and proclaims, "I've fallen flat on my flute!" Loosely based on the Between the Sheets cocktail, which was purportedly served in French brothels as an aperitif in the 1930s, this drink will wet the whistle of any amorous flutist.

¾ ounce London Dry gin
¾ ounce white rum
¾ ounce Cointreau
¼ ounce fresh lemon juice
2 ounces sparkling wine
Orange peel, for garnish

Shake gin, rum, Cointreau, and lemon juice with ice and strain into a champagne flute. Top with sparkling wine and garnish with an orange peel.

BIRD OF PARADISE

With scanty Polynesian costumes and implied beach sex, director King Vidor's South Seas romance *Bird of Paradise* (1932) is a racy, tropical fantasy. For additional entertainment purposes, the film offers sea turtle surfing, mouth-to-mouth feeding, grass surfing (with feral pigs), shark attacks, and killing fish with tennis rackets.

When Johnny Baker's yacht appears on the shores of a nameless tropical island in the Pacific, he is saved from certain death by beautiful native Luana (Dolores del Río), the chieftain's daughter. Johnny (Joel McCrea) falls in love with her, even though she is betrothed to another, steals her away, and the two retreat to an even more remote island until a local volcano erupts. Only through ritual can Luana save her people from the fiery blast, so she

sacrifices herself while Johnny sails away back to civilization.

While Dolores del Río's naked swim (she was wearing a sheer suit) caused public outcry at the film's release, today we cocktailers clutch our pearls at another scene; in an unthinkable act, the members of the yacht party toss their ice overboard to astonish island natives. It makes for a big mixed-drink-related scene and sets up the tragic narrative of a civilized (cocktail drinking) Romeo and a native (fruit

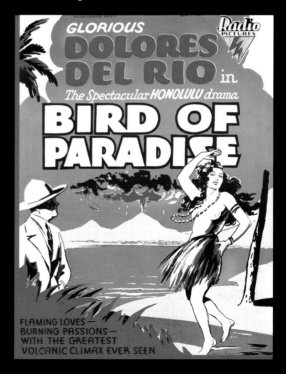

Promotional ad promising burning passion and a volcanic climax. ▶

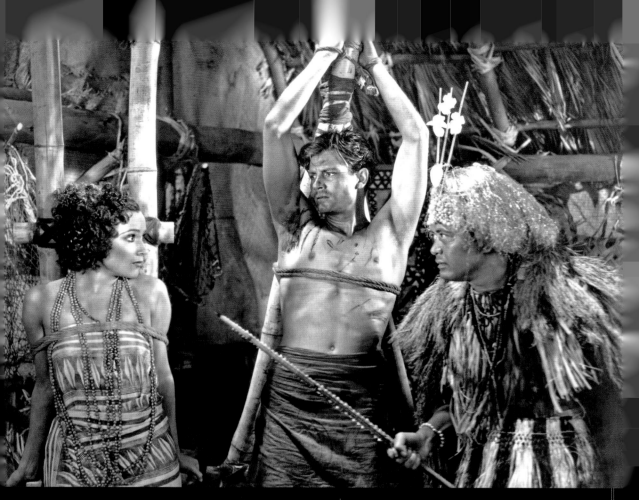

Are you tied up here often?

eating) Juliet who enjoy a brief passion before their respective worlds rend them apart. Of course, the true forbidden fruit was the love affair between Johnny and Luana, a verboten interracial liaison.

Mexican actress Dolores del Río went

Flying Down to Rio (see page 188) and *Madame Du Barry*. Joel McCrea acted in a few other ribald films before eventually making an illustrious career in Westerns. Neither he nor his companions ever abused ice similarly on-screen again.

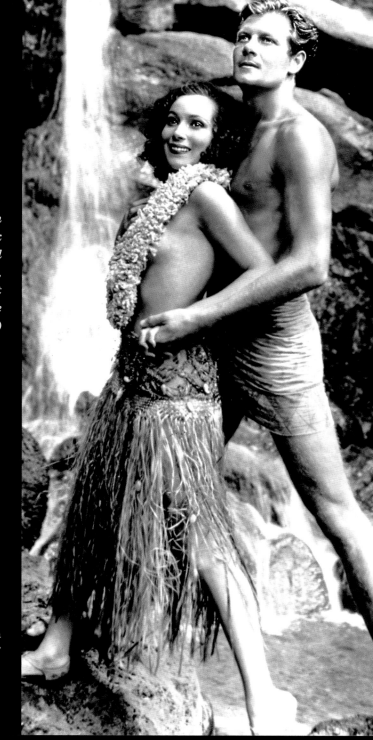

> *"Johnny, you're out of luck. No blondes."*
>
> —CHESTER
> (RICHARD GALLAGHER)

Ice is called "stiff water" in the film, which is the inspiration for this tropical drink that would not be out of place in an island paradise. Think of the mix as a refreshing, boozy slushie where ice chunks are part of the appeal. To make crushed ice, use a Lewis bag and mallet (see page 233) or blender.

¾ ounce dry curaçao
1 ounce cream of coconut
¾ ounce fresh lime juice
¼ ounce dark rum
Freshly grated nutmeg, for garnish
Mint sprig, for garnish

Shake rum, curaçao, cream of coconut, lime juice, and dark rum vigorously with ice. Pour into a rocks glass with ice and garnish with nutmeg and a sprig of mint.

Dolores del Rio and Joel McCrea topless at the waterfall. ▶

BLONDE VENUS

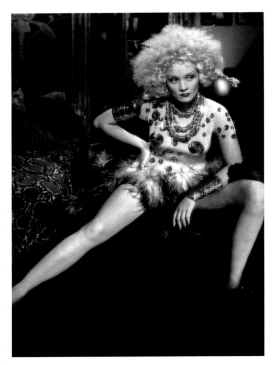

Dietrich stretching her legs.

Marlene Dietrich's box-office super-stardom continued with *Blonde Venus* (1932), a perfect vehicle for her wide-ranging talents. She is magnificent as she journeys through the film's locations: Paris, Long Island, and skid row in New Orleans.

Playing Helen Faraday, a housewife who must return to the stage to pay her sick husband's medical bills, Dietrich's character becomes mistress to wealthy politician Nick Townsend (Cary Grant). When her husband, Ned (Herbert Marshall), returns from treatment and discovers she has been unfaithful, he kicks her out of the house. Faraday flees with their young son, and, at a particularly low point, we see her trading sex for a meal to feed her child. Realizing this is no life for her son, she surrenders him to Ned and leaves for Paris to work in the cabarets and becomes an international star.

The plot is flimsy, but it serves the purpose of the Hollywood star vehicle: it provides the opportunity for director Josef von Sternberg to capture his muse in ever-greater costumes and in increasingly atmospheric sets. Highlights include some wild scenes, such as Dietrich emerging from a gorilla costume and then donning a white Afro. Plus there are three musical numbers, including the outrageous song "Hot Voodoo," in which Faraday intones, "burn my clothes, I want to start dancing,

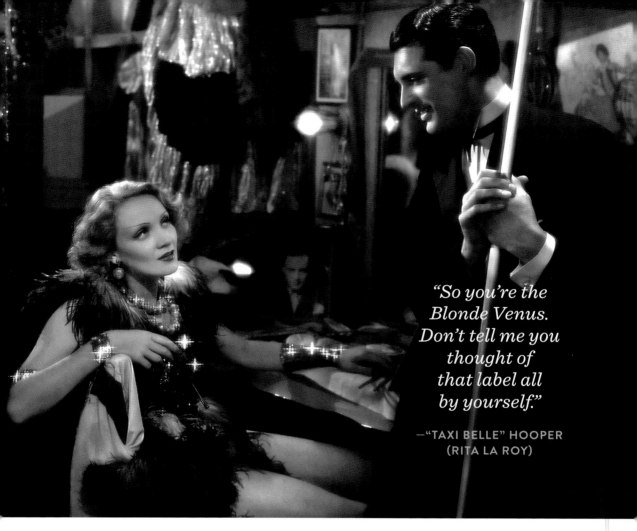

"So you're the Blonde Venus. Don't tell me you thought of that label all by yourself."

—"TAXI BELLE" HOOPER (RITA LA ROY)

Cary Grant visiting the dressing room.

just wearing a smile." From the opening skinny-dipping scene to Dietrich caressing female dancers while in her signature top hat and tails, the movie exerts an intense sexuality that is surprising even today. The film is campy, emotional, dramatic, and a total spectacle—and, of course, the same can be said of its lead actress.

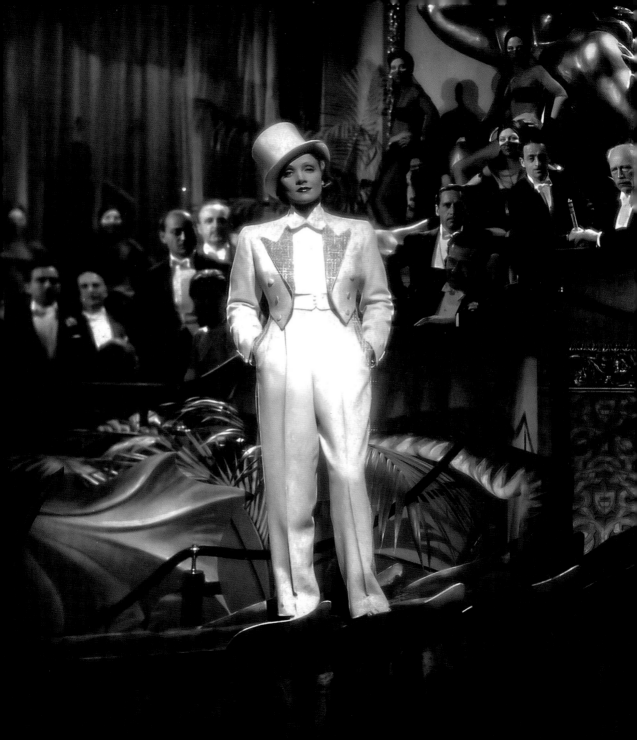

BLONDE VENUS

One kiss of this platinum cocktail and you will be hooked. It is lively and attention-seeking, just like Dietrich. White grape juice provides a novel sweet twist that gives the mix a certain je ne sais quoi. Beware, a few sips and you might want to burn your clothes and dance.

1½ ounces white rum
½ ounce Cointreau
1 ounce white grape juice
1 dash orange bitters
Orange peel, for garnish

Stir rum, Cointreau, grape juice, and bitters with ice. Strain into a cocktail glass and garnish with an orange peel.

◀ Just one of the boys.

RED DUST

Perhaps the most notable of the pre-code "tramp-in-the-tropics" films, *Red Dust* (1932) exudes the kind of hot and steamy atmosphere that leads to a volatile love triangle between a lusty farmer and two women of very different character. Watch next to a fan to cool down.

Good-hearted prostitute Vantine (Jean Harlow), on the run from the Saigon police, shows up during monsoon season at a rubber plantation managed by virile Dennis Carson (Clark Gable). The two have a playful affair until engineer Gary Willis (Gene Raymond) and his classy wife, Barbara (Mary Astor), arrive, prompting Carson to send both Vantine and Willis away so he can seduce Barbara. Barbara falls for Carson, but he has second thoughts. Scorned, she shoots him, and Vantine gets her (injured) man. Directed by Victor Fleming, *Red Dust* is campy and delightfully entertaining.

The film is famous not only for confirming the stardom of both Gable and Harlow—it is one of six movies the two would make together—but because a month into filming, Harlow's husband Paul Bern committed suicide in what erupted into one of the great scandals of early Hollywood. The tragedy did not tarnish the actress's platinum career, however, and a few weeks later she was back in front of the camera.

Harlow would enjoy superstardom for another five years before dying of kidney disease at the ripe age of twenty-six. Twenty years later, Gable would reprise his rubber-grower role in director John Ford's

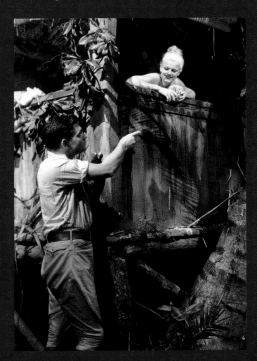

Harlow's infamous bathing scene.

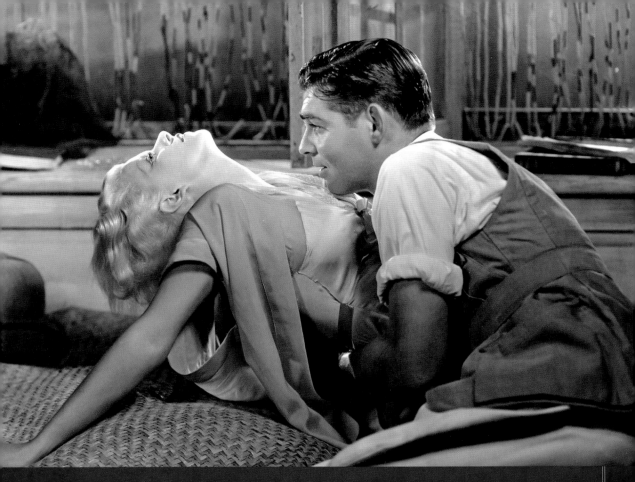

Clark Gable admires Jean Harlow's negligee.

"You can check the wings and halo at the desk."
—VANTINE (JEAN HARLOW)

remake of the film (*Mogambo*), which moves the farm to Africa from Indochina and swaps in Ava Gardner and Grace Kelly, respectively, for Harlow's and Astor's roles. Director Victor Fleming would go on to make two of the most iconic American movies of all time, *The Wizard of Oz* and *Gone with the Wind*.

RED
DUST

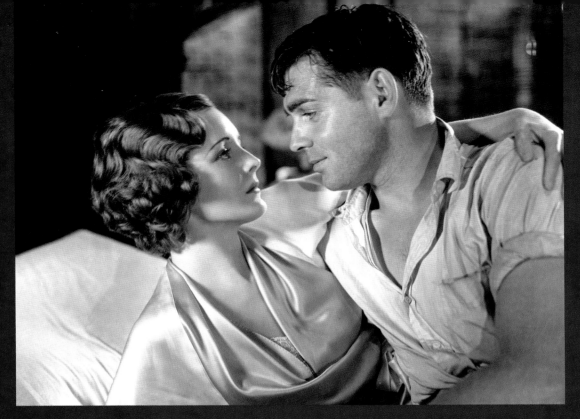

Clark Gable admires Mary Astor's negligee.

In a scene with Dennis drinking at a table, the overseer Mac mentions a yearly shipment of Byrrh. Byrrh is a French fortified wine consumed as an aperitif before dinner. It contains the anti-malarial drug quinine and would have been available in French Indochina (it has been imported to the United States since 2012 but can be difficult to find). This homage to the film Red Dust *re-creates some of Brryh's refreshing flavors with more common ingredients and is a perfect long drink for hot days. Dennis would approve.*

1½ ounces red wine
¾ ounce white rum
¾ ounce white grape juice
3 ounces club soda
Orange peel, for garnish

In a highball glass, combine wine, rum, and grape juice over ice. Top with club soda and garnish with an orange peel.

ONE WAY PASSAGE

Doomed love is the subject of the adorable cruise-ship romance *One Way Passage* (1932). One of the best "four-hankie" tearjerkers of the pre-code era, the film's pacing, mood switches, and charm prevent viewers from questioning the illogical plot. Dan Hardesty (William Powell) and Joan Ames (Kay Francis) meet in a Hong Kong bar and hit it off while each conceals a vital piece of information; he is wanted for murder, and she is fatally ill.

The plot is set in motion with a cocktail, and overseeing the fateful encounter of the lead characters is a Hong Kong bartender (Mike Donlin). He makes the duo a "paradise cocktail" that becomes a plot thread. The trouble is, sleuthing fans of the film have misidentified this as *the* Paradise cocktail from Harry Craddock's *Savoy Cocktail Book* (1930). Craddock's mix of gin, apricot brandy, and orange juice—essentially a fancy gin and juice—is decidedly not what is prepared before us on-screen.

In the film, the bartender stirs-slash-frappés a clear drink, adds something from another glass, prepares a chilled glass with a rim of either salt or sugar, pours in the still-clear liquid, and then adds both an olive and a twist on top. The bartender also utters something to the effect of "Gotta wait a minute to let the oil sink in," presumably referring to the olive brine because he has not twisted the citrus yet. Even if we weren't so off the mark visually, the bartender also explains he was making a similar drink when the earthquake hit San Francisco in 1906—too early for it not to show up again until Craddock's book thirty years later.

We can assume that the point of all the drink-making is to help set the scene, and not to present a known cocktail from the canon. Either way, *One Way Passage* is one of the great cocktail-featuring films of any age. Zippy dialogue, funny characters, and even the inevitable ending make for a touching romance that exudes a breezy magic.

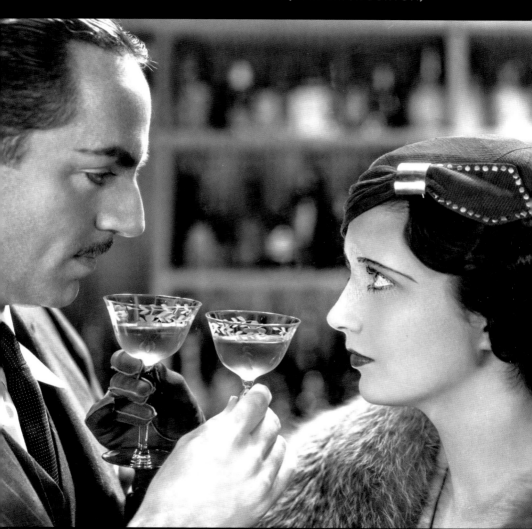

"No more parties, no more cigarettes,
no more dancing, and no more cocktails!"

—THE DOCTOR (FREDERICK BURTON)

Kay Francis and William Powell enjoy Paradise cocktails

PASSAGE
TO
PARADISE

Olives likely made their way into mixed drinks in the late nineteenth century and first appeared in print as "Queen olives," indicating the large Spanish variety grown around Seville. There are scant few early classic cocktails that are garnished with both an olive and a twist, but one such recipe comes from 1906 (the same year as the San Francisco earthquake). Dubbed the H. P. Whitney cocktail, it was named for millionaire Harry Payne Whitney and is similar to what we see constructed on-screen. The mix features a wonderful play between citrus and brine, and even works with a sugared rim.

2 ounces London Dry gin
1 ounce dry vermouth
1 bar spoon kirschwasser
1 dash orange bitters
Orange peel, for garnish
Cocktail olive, for garnish

Stir gin, dry vermouth, kirschwasser, and bitters with ice. Strain into a cocktail glass and garnish with an orange peel and an olive.

THREE ON A MATCH

Mervyn LeRoy's *Three on a Match* (1932) crammed headlines, history, sociology, sex, alcohol, drugs, adultery, kidnapping, blackmail, and suicide into sixty-three minutes, as well as Humphrey Bogart, Lyle Talbot, Glenda Farrell, and of course, Warren William. The title refers to a trio of childhood friends, wild Mary (Joan Blondell), studious Ruth (Bette Davis), and snobby Vivian (Ann Dvorak). The jinx of lighting three cigarettes from the same match will come to haunt one of them, but which?

America was gripped by the March 1932 kidnapping of Charles Lindbergh's baby and the heroic aviator's search for his child. When *Three on a Match* was released in October 1932, the child's body had been found but no arrest had been made.

The American public was not ready for a kidnapping film and that goes a long way in explaining the initial negative reaction to LeRoy's fast-paced and wild drama.

The story follows Ruth, Mary, and Vivian, now all grown up. Vivian is doing the best of the three because she married successful lawyer Robert Kirkwood (Warren William). Unfortunately, she is also the least happy. Vivian leaves Robert for gambler Michael Loftus (Lyle Talbot) and takes her child, Robert Jr. (Buster Phelps), with her. She then becomes a drug addict but in a moment of rare enlightenment returns the boy to his father. Meanwhile, her debonair lawyer husband has created a thrupple for himself by falling in love with her friend Mary and hiring her other friend Ruth as a governess. It all ends badly when Vivian's boyfriend kidnaps Robert Jr. for ransom in order to pay off his debts to gangster Ace (Edward Arnold). As all the bad choices lead to tragedy, Humphrey Bogart (in an early role as gangland heavy Harve) arrives on the scene and presides over the film's intense denouement.

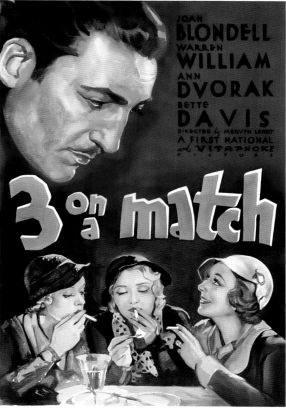

The "King of Pre-Code," William Warren, looks over the leading ladies in an ad for the film.

With *Three on a Match*, director LeRoy continued a streak of films blistering with social critique—from *Little Caesar* (page 26) to *I Am a Fugitive from a Chain Gang*. He would also bring a Depression sensibility to his musical comedy *Gold Diggers of 1933* (page 164) in the astonishing Busby Berkeley number, "Remember My Forgotten Man."

◀ Bette Davis as Ruth Wescott, Joan Blondell as Mary Keaton, and Ann Dvorak as Vivian Revere, all lighting their cigarettes on the same match.

"Will ya stop remindin' me of heaven, when I'm so close to the other place?"

—MARY KEATON (JOAN BLONDELL)

THREE ON A MATCH

Mary, Ruth, and Vivian each have something to love in this three-part cocktail. The mix highlights the camaraderie between fruity sloes and whiskey along with herbaceous vermouth. Sloe gin, made from the fruit of the blackthorn plant, was popular before Prohibition and appears in drinks such as the Charlie Chaplin (see page 234) and the Sloe Gin Fizz. It is a great cocktail to drink with friends—just remember, it's bad luck to light three cigarettes with one match.

1 ounce sloe gin
1 ounce rye whiskey
1 ounce sweet vermouth
3 maraschino cherries, for garnish

Stir sloe gin, whiskey, and sweet vermouth with ice.
Strain into a cocktail glass and garnish with cherries.

Vivian Revere (Ann Dvorak) leaps to her death. ▶

TROUBLE IN PARADISE

Miriam Hopkins, "the Georgia Peach," was the favorite of two great Paramount directors, playing a dancehall girl in Rouben Mamoulian's *Dr. Jekyll and Mr. Hyde* (see page 70) as well as a feisty jewel thief in Ernst Lubitsch's comedy *Trouble in Paradise* (1932). Lubitsch would also go on to cast her as the throbbing heart of the ménage à trois in *Design for Living* in 1933 (see page 196). It's easy to see why both were smitten; she is smart and refined while volatile enough to inhabit some of the era's most intense roles (see *The Story of Temple Drake*). It is difficult to imagine another actress pulling off the sparkling-yet-streetwise nuance necessary to match Lubitsch's mix of suave and risqué. Her versatility is on full display here in her breakthrough role.

Ernst Lubitsch is credited with helping create the modern musical (see 1929's *The Love Parade*) as well as the romantic comedy genre in *Trouble in Paradise*. The "Lubitsch touch"—a meld of European sophistication frappéd with sexual innuendo—became a much-emulated style. The film sizzles with chemistry between the principal characters while just staying on this side of acceptable. Censors did not agree; when the code was enforced, *Trouble in Paradise* was not seen again until 1968.

GASTON MONESCU (HERBERT MARSHALL):

"How would you start?"

WAITER (GEORGE HUMBERT):

"I would start with cocktails."

Gaston Monescu (Herbert Marshall), a professional thief and confidence man masquerading as a baron, meets Lily (Hopkins), a clever pickpocket. After moving in together, they decide to rob Madame Mariette Colet (Kay Francis), a wealthy perfume manufacturer. Kay Francis, the best-dressed woman in Hollywood at the time, does not disappoint. Fashion and passion ensue as Gaston must choose between Lily and Mariette in a sexual rivalry

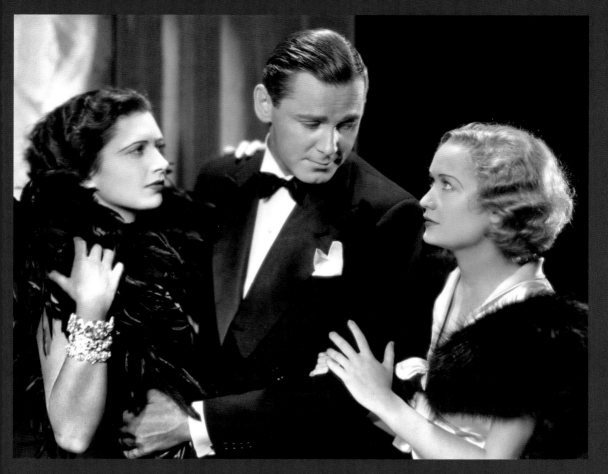

Herbert Marshall, Kay Francis, and Miriam Hopkins learn three is a crowd.

decided more by banter than bedroom.

Like watching a kettle boil in the most stylish way possible, Lubitsch's slow-burn masterpiece seems to teach us that life's greatest gifts—love and time—are thieves that we enjoy anyway.

Kay Francis enjoys a cocktail.

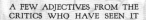

A FEW ADJECTIVES FROM THE
CRITICS WHO HAVE SEEN IT

*"Hollywood previews indicate that Trouble in Paradise
or Farewell to Arms will be voted the year's best."*
—WALTER WINCHELL

*"Best of Lubitsch pictures . . . so super-swell that to
do it justice one would have to invent at least ten
new adjectives . . . will delight any member of any
audience anywhere . . . if you can't do a stand-out
business with it . . . then it's no use going on."*
—HOLLYWOOD REPORTER

*"One of the most thoroughly delightful comedies of the
season . . . he has injected belly-laughs, chuckles,
romance, beauty . . . Lubitsch again steps out and sets
a new style of treatment."*
—MOTION PICTURE HERALD

Ernst LUBITSCH'S

TROUBLE IN
PARADISE

WITH KAY
MIRIAM
HOPKINS FRANCIS
HERBERT
MARSHALL
CHARLIE RUGGLES
EDWARD EVERETT HORTON
A Paramount Picture

We're not in the Garden of Eden anymore in this suggestive ad for the film.

LUBITSCH TOUCH

The idea of a "Lubitsch touch" was created by a PR department, so it is difficult to pinpoint precisely what it is. Legendary director Billy Wilder said it was "the joke you didn't expect." Film journalist Herman Weinberg argued it has something to do with "utilizing the power of the metaphor by suddenly compressing the quintessence of [Lubitsch's] subject in a sly comment." All agree the films have wit, nuance, and sophistication. This cocktail is a tipple inspired by the playful genius.

1½ ounces brandy
1 ounce white rum
½ ounce fresh lime juice
½ ounce apricot liqueur

Shake brandy, rum, lime juice, and apricot liqueur with ice and strain into a cocktail glass.

CALL
HER
SAVAGE

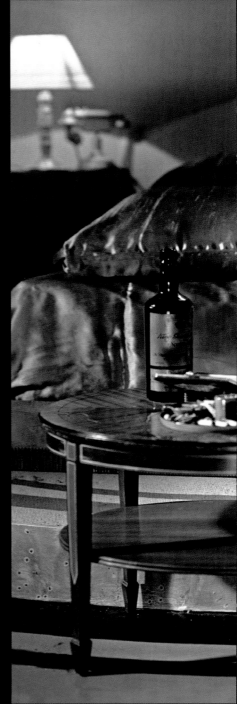

F amed silent-movie-era actress Clara Bow stars in this wildest of wild rides as Texas rich girl Nasa Springer. As if to outdo every over-the-top film of the era, Bow's talkie comeback is a cinematic bucking bronco replete with transparent tops, cross-dressing, prostitution, attempted rape, sexually transmitted diseases, and S&M. *Call Her Savage* (1932) transforms Bow, the sexually liberated "It" girl of the 1920s, into a hot-tempered cat-fighter hell-bent on self-destruction.

Teenaged Nasa rebels against her father Pete (Willard Robertson) and marries rich playboy Lawrence Crosby (Monroe Owsley), who ruins her wedding night and abandons her. Just as she realizes she is pregnant, her father also abandons her, reducing her to poverty and prostitution. While Nasa is street-walking for cash, a child-molesting drunk in her boardinghouse starts a fire that kills her baby. Meanwhile, a childhood friend, the Native American Moonglow (Gilbert Roland), is searching for her because her grandfather has left her an inheritance.

Bow enjoying some "me time" with a bottle. ▶

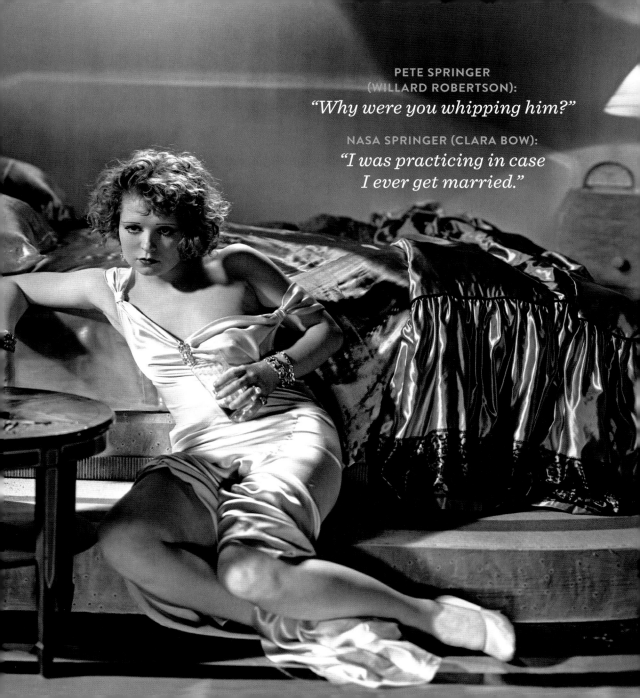

PETE SPRINGER
(WILLARD ROBERTSON):
"Why were you whipping him?"

NASA SPRINGER (CLARA BOW):
*"I was practicing in case
I ever get married."*

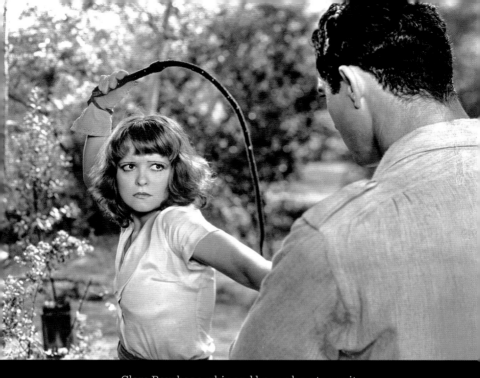

Clara Bow has a whip and knows how to use it.

Call Her Savage is certainly savage. It abounds with violence: throwing, slapping, punching, whipping, and wrestling. At a particular low point, Bow heaves a bottle through a mirror. As the film, and Nasa, reels from mood to mood, there is always witty banter to keep the runaway train on the rails, along with some genuinely hilarious situations. Of particular note is an early—and conspicuously nonjudgmental for its time—portrayal of homosexuality set in a Greenwich Village restaurant with a duo of singing drag queens. None of the movie's taboo subjects are of vital importance, however, because the undercurrent of the story is racism; Nasa is revealed to be half Native American. Her fitting punishment is to be married to Native American Moonglow, who happens to be the most handsome and sympathetic character in the film. Unhinged and uninhibited, *Call Her Savage* is a pre-code creation as coarse as its heroine.

GREENWICH VILLAGE

It is intriguing that Nasa's escort Jay Randall (Anthony Jowitt) knows exactly where to go slumming in New York's Greenwich Village. The restaurant episode ends with a brawl almost as extravagant as Marlon Brando's in Guys and Dolls, *but not before we are treated to singing waiters dressed as maids. It's a magnificent scene, and we can imagine that the patrons of the bar might have been drinking something like this small cocktail that functions as a shot.*

1 ounce London Dry gin
¾ ounce crème de violette
(or crème de cassis)
¼ ounce absinthe

Shake gin, crème de violette, and absinthe with ice and strain into a Nick & Nora or large shot glass.

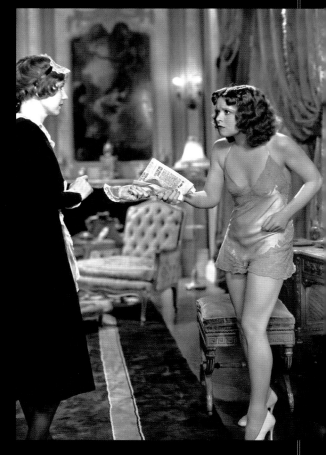

Just another day in heels and a negligee.

THE SIGN OF THE CROSS

At the outset of Cecil B. DeMille's *The Sign of the Cross* (1932), actress Claudette Colbert lounges naked in a bath of ass's milk, the level of which is certainly below that required by censors because she is clearly exposed. DeMille's Judeo-Christian epic by way of romp through ancient Rome devolves from there, hanging on a thin plot of conversion to Christian values while treating viewers to pagan orgies and one of the more notorious erotic dances in cinema history. Then, after the lead characters display their religiosity, they are summarily eaten by lions.

The question on every viewer's mind while watching actor Charles Laughton play Emperor Nero as Rome burns or Joyzelle Joyner perform her famed lesbian seduction in the "Dance of the Naked Moon" is how all this is supposed to make anyone reject the old pagan gods. They are simply too much fun. By comparison, DeMille's Christian scenes have all the appeal of a time-share presentation during which it's best to refill cocktail glasses.

Brutal and debauched, *The Sign of the Cross* was a cinematic landmark and a huge hit. It restored DeMille's status, which had been momentarily in question following the failure of two pre-code oddities, *Madam Satan* (1930) and *The Squaw Man* (1931). He would make more epics, including *Cleopatra* (1934) and *The Ten Commandments* (1956). Unfortunately, *The Sign of the Cross*'s success came at a price. Many Catholics felt that DeMille had appropriated the mythology of the Christian martyrs in order to glorify paganism. Negative publicity about this film and numerous others in 1933 led to the formation of the Catholic Legion of Decency, which played a pivotal role in the reconstitution of the code. This film is almost directly responsible for increased censorship in later years; paganism and sexual license could not be so alluring. Additionally, the Circus Maximus scenes— Amazons beheading pygmies, bears being

Claudette Colbert having a drink while in the bath. ▶

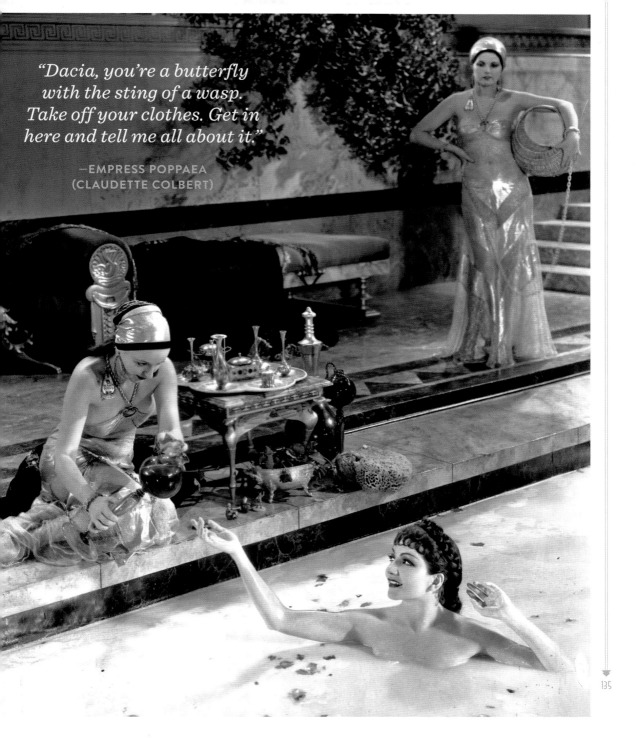

"Dacia, you're a butterfly
with the sting of a wasp.
Take off your clothes. Get in
here and tell me all about it."

—EMPRESS POPPAEA
(CLAUDETTE COLBERT)

speared, tigers eating humans—horrified theatergoers. During the opening week in New York City, women in the audience not only screamed; some fainted, and more walked out. The reissue of the film was held up until Paramount cut all the "immoral" content; thankfully for us, the DeMille Estate and the Packard Foundation restored the censored scenes in 1993.

Excellent acting by Fredric March (Marcus Superbus) and Elissa Landi (Mercia) impress, even as Laughton steals the film with his campy take on pure evil. Laughton played a number of crazed characters in the 1930s, including Dr. Moreau in the infamous *Island of Lost Souls* (page 138).

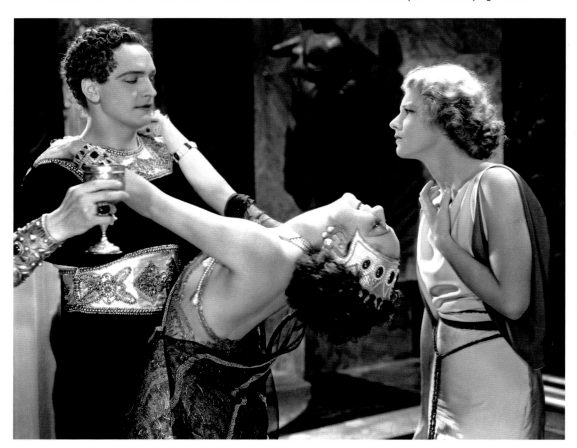

Fredric March has a drink and Joyzelle Joyner and Elissa Landi do not.

NAKED MOON

— MAKES 6 TO 8 SERVINGS —

Cornucopia, the symbol of abundance and fertility, makes its appearance in the movie's orgy scenes. The woven baskets are filled with grapes, which are symbols of plenitude and debauchery to the worshippers of the Roman god Bacchus. Let wine flow prodigiously with this sangria variation, fit for watching (or howling at) a naked moon. In a boon to imbibers, The Sign of the Cross *features an intermission for more cocktail-making.*

1 (750 mL) bottle red wine
4 ounces London Dry gin
4 ounces white grape juice
4 ounces fresh orange juice
1 lemon, sliced
1 cinnamon stick
1 cup club soda

In a large pitcher, combine red wine, gin, grape juice, orange juice, lemons, and cinnamon, and cool in the refrigerator at least 1 hour. Before serving, add club soda and stir to combine.

ISLAND OF LOST SOULS

It was not only sexually explicit content or gangster heroes that concerned the censors; the new horror genre of the 1930s brought into question the nature of humanity's relationship to the divine and cast doubt on the existence of God. In the case of *Island of Lost Souls* (1932), Dr. Moreau (Charles Laughton) uses vivisection—surgery without anesthetic—to meld beasts with humans and create a race of freakish hybrids. He has, in fact, become God on his island. The film features sex, violence, and horror all wrapped up in a gruesome and blasphemous nightmare.

Edward Parker (Richard Arlen) finds himself ship wrecked on an island inhabited by "strange-looking natives." Lording it over them is the whip-wielding scientist Dr. Moreau—played flawlessly by the inimitable Laughton. These "natives" include the fur-covered Sayer of the Law (Bela Lugosi) and the bewitching Lota the Panther Woman. The latter, played by a nineteen-year-old former dental hygienist named Kathleen Burke (she won the part in a Paramount contest), became the centerpiece of a sexualized ad campaign. As part panther, she adds a touch of bestiality to the already-awkward mix of exoticism and blasphemy.

When Parker walks into a scene of screaming horror in a "House of Pain," he decides it's time to bolt—of course, with the aforementioned panther-woman, whom he has kissed and now wants to save.

Sadist Dr. Moreau (Charles Laughton) keeps his creatures at bay. ▶

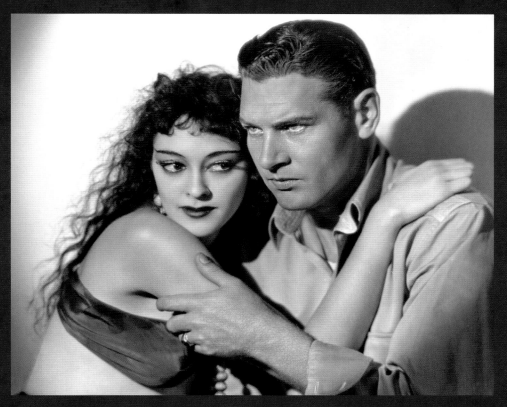

Parker (Richard Arlen) falls for Lota the Panther Woman, played by Kathleen Burke.

Moreau sinks the escape boat, but luckily Parker's fiancée arrives to check up on how her future husband gets on without her (not so great). The hybrid creatures revolt against their God-creator—giving Laughton the opportunity to thrash about in one of pre-code's most memorable death scenes—while the young couple sails away.

Island of Lost Souls was banned in a multitude of countries and became one of the most-chopped-up films of the era. No censor board could tolerate it. Incredibly transgressive, it is also visually arresting, with an Art Deco laboratory and glowing highlights on fuzzy shoulders. Much of the film's philosophical payload concerns the requisite suffering of God's creatures, whether human or animal, and exploring where the line between sentient "us" and "them" lies. All the silly makeup and the unruly sex-kitten, or panther, are just more reasons to watch.

*"Not to go on all fours, that is the law.
Are we not men?"*

—SAYER OF THE LAW (BELA LUGOSI)

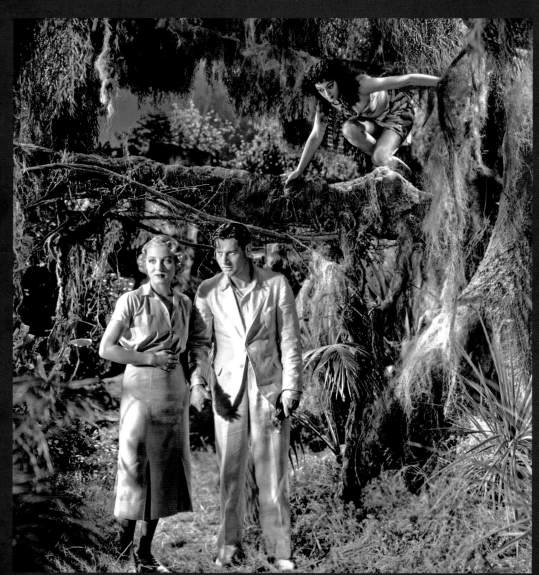

HOUSE ⊖ PAIN

If you found yourself shipwrecked on an island in the South Seas, this tiki-inspired cocktail would make a wonderful refreshment. Cinnamon syrup is an essential ingredient for making tiki drinks and is also great to have on hand in wintertime for cocktails such as hot toddies. It is available in grocery stores but also a cinch to make (recipe follows). The spiced syrup brings out the best in rum, grenadine, and Angostura bitters in this winning mix.

2 ounces rum

¾ ounce fresh lime juice

½ ounce cinnamon syrup (see recipe below)

1 bar spoon grenadine

1 bar spoon absinthe

1 dash Angostura bitters

Lime wedge, for garnish

FOR THE CINNAMON SYRUP

1 cup water

1 cup sugar

2 teaspoons ground cinnamon

Shake rum, lime juice, cinnamon syrup, grenadine, absinthe, and bitters with ice. Pour into a rocks glass and garnish with a lime wedge.

In a medium saucepan over medium-high heat, bring water, sugar, and cinnamon to a boil. Remove from heat and strain into a sealable jar. The cinnamon syrup will keep, sealed, for up to 2 weeks.

◀ Parker's fiancée, played by Leila Hyams, arrives to see how her beau is doing. Lota is about to pounce.

THE BITTER TEA OF GENERAL YEN

Director Frank Capra's bitter box-office flop *The Bitter Tea of General Yen* (1933) was denounced upon release because of its negative portrayal of Christian missionaries. But the film would have caused an uproar anyway due to its bold portrayal of an interracial romance. Set in China during the country's civil war, Megan Davis (Barbara Stanwyck) arrives in Shanghai to marry her longtime fiancé, Bob (Gavin Gordon). When she accompanies Bob to help save a group of orphans, the two get separated and she finds herself the captive of General Yen (Nils Asther). What ensues is Megan's spiritual and sexual awakening. She has an erotic dream about Yen and even becomes (symbolically, at least) the general's concubine in order to replace the one who betrays him—thief Mah Li, played by Japanese actress Toshia Mori.

A romance starring one of the era's famous blondes stricken with Stockholm syndrome was simply too much for American audiences, and the film was pulled from theaters after just a few days. Beautifully composed and wonderfully costumed, the movie is a work of art. In fact, Capra helped define "arty" for the 1930s; cinematographer Joseph Walker used a variable diffusion lens to add an aura of intrigue and soft lighting—although the content could not be softened. The film is a minefield of

> *"East or West, men seldom deviate very far from their main passion in life."*
>
> —MEGAN DAVIS
> (BARBARA STANWYCK)

racial, political, and sexual issues including non-Asian actor Nils Asther playing General Yen. The problem is, dismissing the film as merely "progressive for its time" doesn't give credit to how subversive it is, calling out American imperialism, religious zealotry, gender roles, and more.

An interracial romance was just too much for early 1930s audiences. ▶

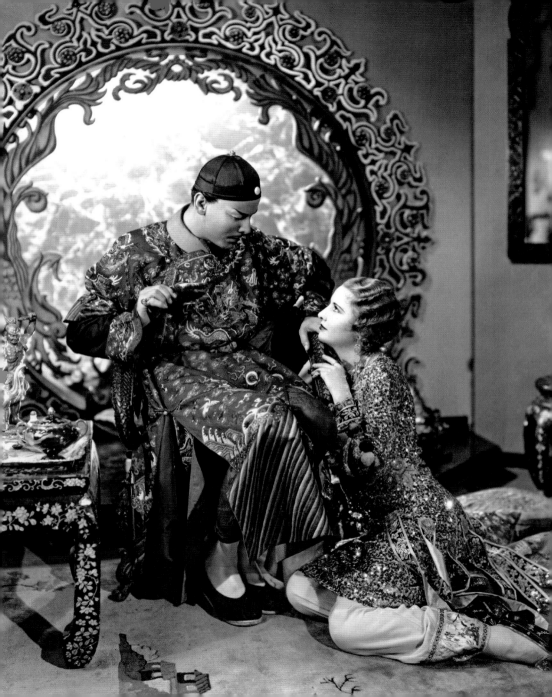

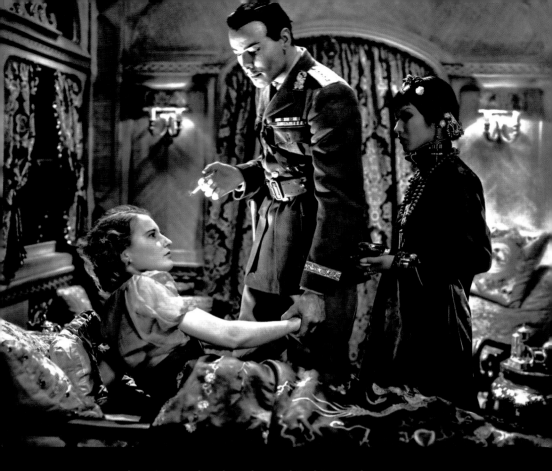

Barbara Stanwyck, Nils Asther, and Toshi Mori share a moment.

When Stanwyck was asked why the film failed, she said: "Women's groups all over the country protested, wrote letters to exhibitors, saying we were condoning miscegenation." (Marriage between races was illegal in thirty states, but the code only specified romance between "the white

his film's failure but survived the setback and went on to a storied career. He would make some of the most revered films of all time, including *Mr. Smith Goes to Washington*, *It's a Wonderful Life*, and *It Happened One Night* (see page 208), earning three Academy Awards for Best Director out of

They found a love they dared not touch!

BARBARA
Stanwyck IN
"The BITTER TEA
OF GENERAL YEN"
with Nils Asther — Walter Connolly
A FRANK CAPRA PRODUCTION
A COLUMBIA PICTURE

◄ Interracial romance would be forbidden by the Production Code a year later.

145

LOTUS BLOSSOM

Famed drinks writer Charles H. Baker visited Shanghai just before the outbreak of the Chinese Civil War in 1927. He recorded cocktails he found there in his book The Gentleman's Companion, *which provides the historical basis for the contents of this drink. The mix is inspired by the film's moonlit denouement; before Yen drinks his lethal tea, he addresses Megan and says that she is "young and pale as a lotus blossom, which blooms at night."*

1½ ounces white rum
¾ ounce absinthe
½ ounce Luxardo maraschino liqueur
¼ ounce fresh lemon juice
1 egg white

Shake rum, absinthe, maraschino liqueur,
lemon juice, and egg white vigorously with ice.
Strain into a cocktail glass.

SHE DONE HIM WRONG

Mae West, the famous playwright of *Sex, The Drag, and Diamond Lil*, had already been to jail in New York on obscenity charges before she ever strutted across the screen in *She Done Him Wrong* (1933). Eye-rolling, cooing, and wisecracking her way into American conscious-ness, here was a middle-aged woman who threw her weight around—especially the forward and aft bits—to become the exagger-ated icon of womanliness.

West is Lady Lou, a Bowery bar-room singer contending with mul-tiple gangland suitors plus secret federal agent Captain Cummings (Cary Grant). Her boss Gus Jordan (Noah Beery), meanwhile, is running a counterfeiting and prostitution ring. Handling the complex web of characters with saucy aplomb, West schools us in how to successfully mix busi-ness with pleasure.

West was unique in that she did not play ingenues discovering their seduc-tive powers while struggling to survive. Her characters have struck gold already and are understood to have entertained multiple sex partners. West's Lady Lou is on the flip side of love and plays the fairy godmother of the game—one who may

With the arrival of West on-screen, curvy was suddenly in. ▶

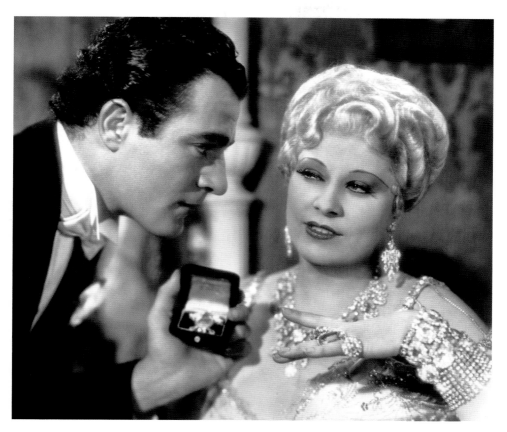

Lil is covered in jewelry, but she'll always take more.

still sashay, but lives by her wits and isn't afraid to pass on her wisdom. Campy to the extreme and a one-of-a-kind outsider, West was able to push sexual boundaries because audiences laughed knowingly along with her, never either identifying or lusting, but simply in on her big off-color joke. Her deftness in this regard is a wonder to behold.

While not Hollywood's first portrayal of a smart and powerful woman, none so assuredly always held all the cards. West's force is such that the production garnered a nomination for Best Picture; it was her first and last nod. *She Done Him Wrong* was successful enough to help save Paramount from bankruptcy and launch its lead to superstardom.

DIAMOND RING

At the film's conclusion, Captain Cummings removes all the rings Lady Lou presumably won from other suitors and slips on a diamond engagement ring. He will keep her out of jail, but she may be entering another prison altogether. Although Cary Grant had acted in prior films, Mae West liked to claim she discovered him. Their chemistry on-screen is as delightful as this cocktail. Note that Old Tom gin is an older style than the London Dry you may be used to and adds a touch more sweetness.

1½ ounces Old Tom gin
(or substitute London Dry)
½ ounce fresh lemon juice
¼ ounce Luxardo maraschino liqueur
2 ounces club soda
Maraschino cherry, for garnish
Lemon peel, for garnish

Shake gin, lemon juice, and maraschino liqueur with ice. Strain into a highball glass, top with club soda and garnish with a cherry and lemon peel.

Mae West liked to claim she discovered Cary Grant. ▶

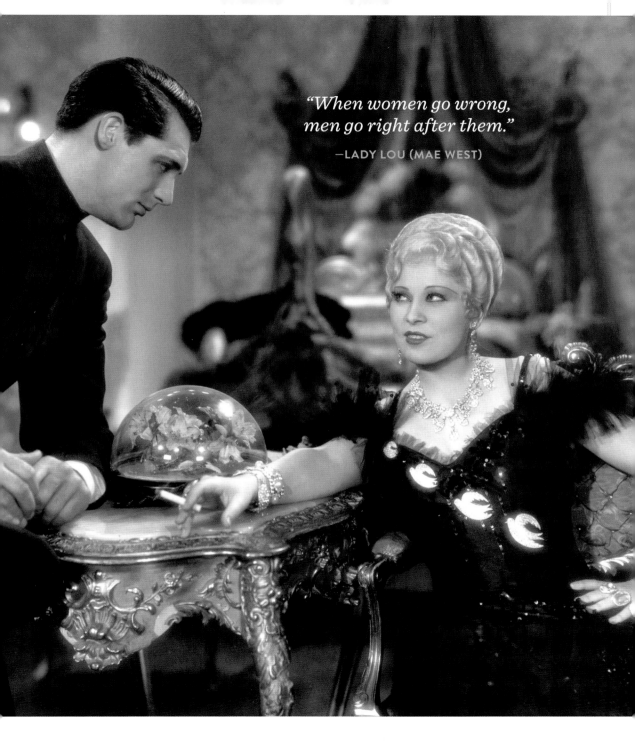

"*When women go wrong,
men go right after them.*"

—LADY LOU (MAE WEST)

42ND STREET

Early talking films were flooded with one-liners and rapid-fire wit, reaching fever pitch in films such as director Lloyd Bacon's backstage musical *42nd Street* (1933). In fact, at one point amid all the jokes a frustrated Bebe Daniels (playing star Dorothy Brock) yells, "Enough of the wisecracks!" Audiences and critics adored the humor. Add musical numbers with mind-boggling choreography by Busby Berkeley, and *42nd Street* was a smashing combination that soared at the box office.

The movie takes a behind-the-scenes view of a cast and crew's heroic attempt to get a flailing production off the ground. Such a voyeuristic lens was a popular vehicle in pre-code films (see *Gold Diggers of 1933* page 164 and *Footlight Parade* page 184); the setup allowed for plenty of chicanery as well as changing-room revelations.

Julian Marsh (Warner Baxter) has fallen on hard times and is hoping to mount one last show before retirement. His lead

Ruby Keeler as Peggy Sawyer getting dancing directions
while Ginger Rogers as Ann Lowell and the rest of dancers observe.

Warner Baxter as Julian Marsh surrounded from lower left:
Ginger Rogers as Ann Lowell, Bebe Daniels as Dorothy Baxter, Una Merkel
as Lorraine Fleming, and Ruby Keeler as Peggy Sawyer.

actress, Dorothy, is divided in her attentions between the show's financial backer, Abner Dillon (Guy Kibbee), and struggling actor Pat Denning (George Brent). Tribulations ensue.

It is hard not to see the plot setup as a metaphor for the struggles of the Great Depression, the reality of which had broken into Hollywood's fantasy world by 1933. Notably, we witness the character Peggy Sawyer (Ruby Keeler), a fresh-faced hopeful new to New York City, faint from hunger. However, despite all odds,

art ultimately triumphs and *42nd Street* is a record of resilience that endures as one of the most influential musicals of all time.

JERRY (HARRY AKST):
*"It seems that little
Lorraine's hit
the bottle again."*

MAC ELROY (ALLEN JENKINS):
*"Yeah, the
peroxide bottle."*

ROSE-COLORED GLASSES

When Peggy is evicted from her apartment, she has no choice but to accompany Pat (George Brent) to his house. Hoping to seduce her, he offers (illegal) drinks, saying, "Just a couple of rose-colored glasses. Let's try them on and see how the world looks." We can imagine a rosy cocktail inspired by the scene that will certainly make the world look better.

2 ounces London Dry gin
¾ ounce raspberry syrup (see page 64)
½ ounce cream
1 dash orange bitters

Shake gin, raspberry syrup, cream, and bitters with ice. Strain into a cocktail glass.

OUR BETTERS

A biting satire of the upper classes, *Our Betters* (1933) is based on a play of the same name by Somerset Maugham. Constance Bennett plays Pearl Grayston, an American heiress who learns on her wedding night that her new husband, Lord George Grayston (Alan Mowbray), married her for money and loves another. Flash-forward five years and Lady Gray has become a hard and cynical force in the British aristocracy. She wants to marry off her younger sister into happier circumstances than her own while juggling two suitors, benefactor Arthur Fenwick (Minor Watson) and lover Pepi D'Costa (Gilbert Roland). When Pearl is caught having sexual relations with the latter in the teahouse on her estate, drama ensues. Will her circle out her as a cad?

If you thought the days of the idle rich were filled with anything but pettiness, insecurity, partner swapping, and catty gossip, you are in for a disappointment. Maugham, via screenwriters Jane Murfin and Harry Wagstaff Gribble, paints the portrait of a group so self-absorbed that its members could be mistaken for today's social media influencers—except that *Our Betters* is amusing. Constance Bennett is radiant, the supporting cast is flawless, and Tyrell Davis's portrayal of a late-arriving dance instructor is perhaps the most flamboyant gay character of the period.

Presenting homosexuality as fashionable was a risky move for director George Cukor, whose own sexual orientation was in question. Cukor would be nominated as Best Director for *Little Women* the same year and later became famous for being a "woman's director" known for coaxing the best performances from actresses such as Katharine Hepburn. Cukor also directed lead male actors to Oscars three times. In *Our Betters*, we can already see his attention to dialogue detail, beautiful staging and smart camerawork that are signatures in his masterpieces such as *Dinner a Eight* (see page 180), *The Philadelphia Story* (1940), and *My Fair Lady* (1964).

(see page 180)

Constance Bennett as sophisticated Lady Pearl

*"What an exquisite spectacle!
Two ladies of title
kissing one another!"*

—ERNEST (TYRELL DAVIS)

Late-arriving Tyrell Davis as a dance instructor steals the show. ▶

Lady Pearl

Named for the heroine of the film—if you can call her that—this cocktail is a luxurious experience. It is elegant but also a little naughty, a combination of anisette and gin with a dash of pineapple and apricot. Mint provides wonderful aromatics. Like its namesake, this beguiling number has a lot of attitude.

½ ounce London Dry gin
½ ounce absinthe
½ ounce apricot liqueur
½ ounce pineapple juice
1 egg white
Mint leaf, for garnish

Shake gin, absinthe, apricot liqueur, pineapple juice, and egg white vigorously with ice. Strain into a cocktail glass and garnish with a mint leaf. Note: It is helpful to smack the mint leaf between the palms of your hands to release its aroma as the drink is garnished.

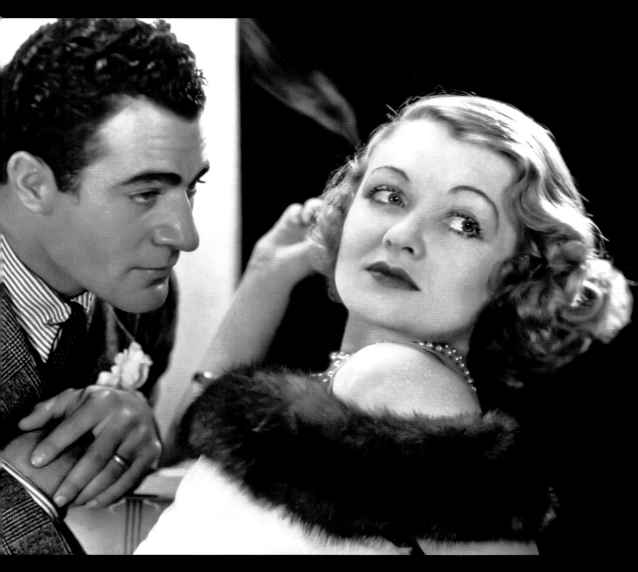

Lady Pearl wearing pearls with Gilbert Roland as smoldering Latin lover Pepi D'Costa.

KING KONG

F ew movies enraptured American audiences like *King Kong* (1933), maybe the most famous of all pre-code films. It is easy to see why, since the blockbuster embodies many of the era's themes; it is a racial adventure film like *Tarzan and His Mate*, a nightmare like *Frankenstein*, and an interspecies love affair similar to *Island of Lost Souls*. Throw in one of cinema's most relatable nonhuman stars and it was a recipe for box-office mania.

The ape appears as a coded figure in several early 1930s films, from *Blonde Venus* (see page 106) to *The Sign of the Cross* (see page 134), but none so prominently as Kong. He is a monstrous stand-in for audiences' deep-seated fears of sexual violation—one that plays out before our very eyes between giant Kong and

Kong holding Fay Wray at the elevated train outside the New York theaters.
◄

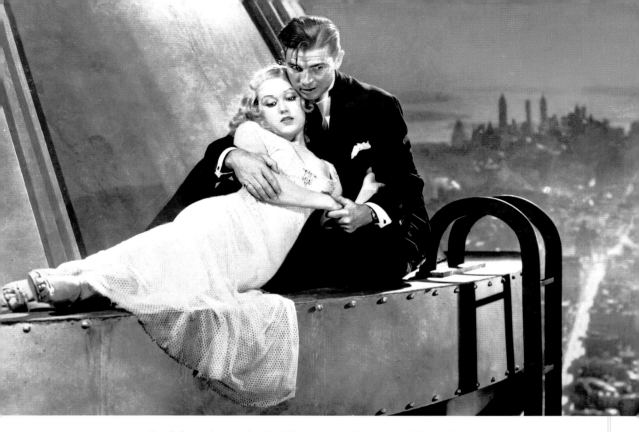

Back from the jungle, Fay Wray as Ann Darrow and Bruce Cabot
as Jack Driscoll hang on to the edge of the Empire State Building.

the small, white maiden Ann Darrow (Fay Wray). Never before had special effects worked so well in conjunction with sound technology to create a convincing narrative from what was, essentially, a kinky fever-dream. Filled with gore and sadism, the film flouted censorship while presenting a monster from another world smashing into the heart of civilization.

Kong is also a symbol of the financial and cultural chaos of the Depression. At the time of the film's release, President Roosevelt had declared a holiday to stop a run on the banks and America was in crisis. Audiences felt the monster was *close*. It is no accident we witness Kong attacking the Sixth Avenue El right outside Manhattan's Radio City theater, where the film played to packed houses.

Fay Wray as Ann Darrow in King Kong's paw.

Inspired by a giant ape that climbs the Empire State Building, this unique cocktail combines whiskey, amaro, and banana liqueur for a kind of Banana Manhattan. The result is as outsized as Kong and a similarly formidable force with a playful side.

2 ounces bourbon whiskey
¾ ounce amaro
(such as Averna)
¾ ounce banana liqueur
1 dash Angostura bitters

Stir bourbon, amaro, banana liqueur, and bitters with ice and strain into a rocks glass with a large ice cube.

"It was beauty killed the beast."

—CARL DENHAM
(ROBERT ARMSTRONG)

GOLD DIGGERS OF 1933

The heroines of Mervyn LeRoy's delightful *Gold Diggers of 1933* (1933) are three plucky but unemployed chorus girls: Carol (Joan Blondell), Polly (Ruby Keeler), and Trixie (Aline MacMahon). We know they are hard up because they steal milk for breakfast the moment we meet them. But as luck would have it, Broadway producer Barney Hopkins (Ned Sparks) offers them parts in his new show—just as soon as he gets money. We are, after all, in the midst of the Depression. Enter neighbor Brad Roberts (Dick Powell), who is secretly wealthy and is willing to underwrite the show—if he can write the songs. The catch is that if Brad reveals his true identity, his high-society brother J. Lawrence Bradford (William Warren) will disown him. But do not worry, the

◀ Gold Diggers with their violins in the "Shadow Waltz."

The ironic number "We're in the Money."

showgirls resolve to teach the snobbish brother a lesson.

Gold Diggers of 1933 has it all; racy dialogue, dance numbers, extravagant costumes, Art Deco sets, and brilliant acting. Plus, Warner Bros. let choreographer Busby Berkeley loose to work his enthralling magic. From the opening gonzo (and ironic) number "We're in the Money"—unforgettably performed by Ginger Rogers with a pig-Latin twist at the end—to the stunningly beautiful and elegant "Shadow

Waltz," the film is a true spectacle. Watch for Berkeley's "Remember My Forgotten Man," which directly addresses the Depression. This was the second of Berkeley's three classic films of 1933, the others being *42nd Street* (page 152) and *Footlight Parade* (page 184).

This comedic film was a change for director LeRoy, better known up to that point for gritty dramas like *Little Caesar* (see page 26) and *Three on a Match* (see page 118). He brought a realistic undercurrent to the fantasy. The movie is an essential pre-code film that acts as a cipher containing all the many elements of the era. It is also delicious entertainment.

PETTIN' IN THE PARK

The hilarious number "Pettin' in the Park" features Dick Powell and Ruby Keeler on a date that grows ever more outlandish and racy. There are cops on roller skates, a scene in a zoo, seasonal fashion changes, nude women (in silhouette), and awkward metal-chastity outfits—presumably to prevent said petting from getting too heavy. Suitably potent and titillating, this heady mix travels easily if you want to take it to the park for a make-out session.

2 ounces applejack
½ ounce dry curaçao
½ ounce raspberry syrup
(see page 64)
Raspberry, for garnish

Stir applejack, curaçao, and raspberry syrup with ice.

Strain into a cocktail glass and garnish with a raspberry.

Joan Blondell as Carol King and Warren William as J. Lawrence Bradford share a drink moment. ▶

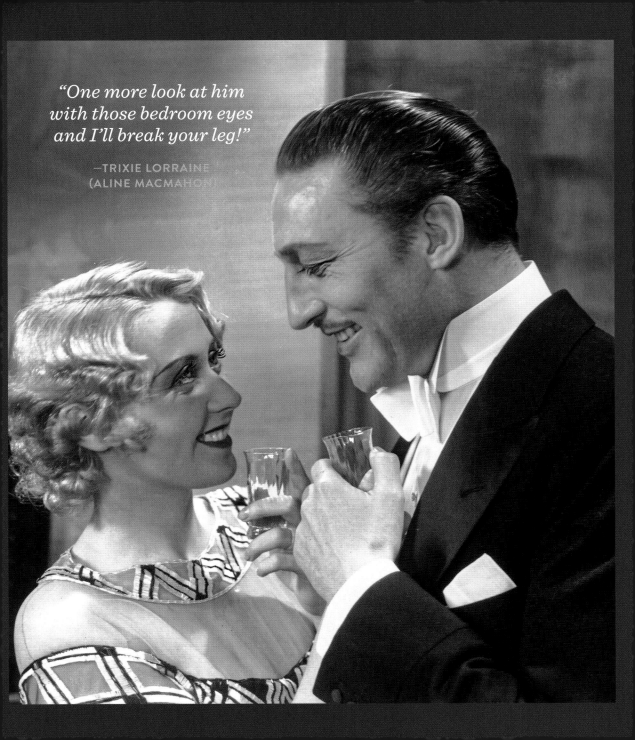

"One more look at him
with those bedroom eyes
and I'll break your leg!"

—TRIXIE LORRAINE
(ALINE MACMAHON)

COCKTAIL HOUR

Too many cocktails by moonlight and you'll find yourself on a walk of shame across a transatlantic liner in last night's dinner gown is just one of the lessons of the irresistibly witty *Cocktail Hour* (1933). Financially independent advertising illustrator Cynthia Warren (Bebe Daniels) is the toast of New York's glittering bohemian crowd when she sets off for Paris to escape a future of matrimony and motherhood. Despite being pursued by a number of handsome suitors, our modern woman isn't a day at sea before she falls for the philandering grandson of a corset-maker, William Lawton (Sidney Blackmer). Only after Warren is deeply hooked is it revealed that "rotter" Lawton is already married—and his wife approves of his dalliances.

Life isn't quite so rosy for free-spirited Warren when the tables of her liberal sexual mores are turned, but as fate would have it, Russian countess and concert pianist Olga Raimoff (Muriel Kirkland) is available to commiserate. Then, because alcohol's ability to lower inhibitions is particularly strong on this vessel, only one cocktail is required for Countess Raimoff to reveal she is a fraud and Tessie Burns from Kansas.

> *"I'm going to get so cockeyed tonight that they'll have to put me to bed with a sponge."*
>
> —CYNTHIA WARREN
> (BEBE DANIELS)

Equal parts romp and womance (with a drinking jag to prove it), *Cocktail Hour* is as effervescent as the bubbly libations served in its party scenes. The snappy dialogue is self-aware, there is plenty of brilliant drunk acting (if it *is* acting), plus the film sports a bevy of quirky supporting personalities. All this is tied together with a beguiling humanness pervading the film's intimate scenes that makes the characters feel especially modern. Add a surprise dramatic ending and the picture delights to the last drop.

Any time can be cocktail hour. ▶

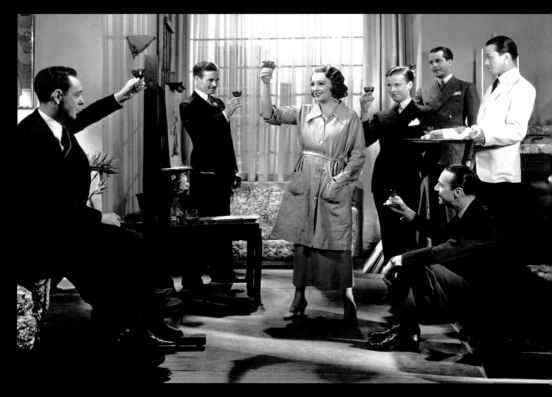

Raise a glass to Cynthia Warren (played by Bebe Daniels).

When Warren's longtime suitor—and, more or less, boss, since he is the only buyer for her illustrations—Randolf Morgan (Randolph Scott), turns up in Europe, he finds Cynthia and Olga in their rooms. He confides to Olga that he is merely playing hard to get in order to convince Cynthia to finally agree to marry him. He also knowingly calls Olga a "Kansas Romanov."

KANSAS ROMANOV

This cocktail's name is a reference to concert pianist Olga's real identity as Tessie Burns from Kansas. Russian-made vodka was rare in the 1930s, and most cocktail historians cite Dr. No (1962) as its first prominent appearance in film. However, the clear distillate makes a significant cameo far earlier, in the film Female (1933), a movie worth seeking out. Here, vodka is combined with cranberry juice, a product Ocean Spray began marketing in 1930.

2 ounces vodka
1½ ounces cranberry juice
1 dash Angostura bitters
2 ounces club soda
Lemon peel, for garnish

In a highball glass filled with ice, combine vodka, cranberry juice, and bitters. Top with club soda and garnish with a lemon peel.

You never know what may happen when you have one too many. ▶

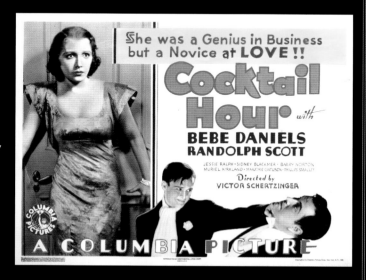

She was a Genius in Business but a Novice at LOVE !!

Cocktail Hour with

BEBE DANIELS
RANDOLPH SCOTT

JESSIE RALPH · SIDNEY BLACKMER · BARRY NORTON
MURIEL KIRKLAND · MAXINE GATSON · PHILLIPS SMALLEY

Directed by
VICTOR SCHERTZINGER

COLUMBIA PICTURES

A COLUMBIA PICTURE

BABY FACE

*B*aby Face (1933) was Warner Bros.' answer to M-G-M's *Red-Headed Woman* (see page 88), and Darryl Zanuck's story matches that film in intensity while offering a broader philosophical indictment of 1930s society. Life is exploitation, and Lily Powers (Barbara Stanwyck) knows this firsthand because her saloon-keeper father has been pimping her out to customers since she was fourteen. When her father dies, Lily and her coworker Chico (Theresa Harris) make their way to Manhattan, where Lily finds work at an international bank. Using sex to get ahead—in overtly phallic imagery we see her climbing her way to the top of the skyscraper—our pre-jaded ingenue embarks on conquests of company men (including a young John Wayne as Jimmy McCoy Jr.) in order to improve her station.

Lily with Chico (played by Theresa Harris), the only person to whom she is loyal.

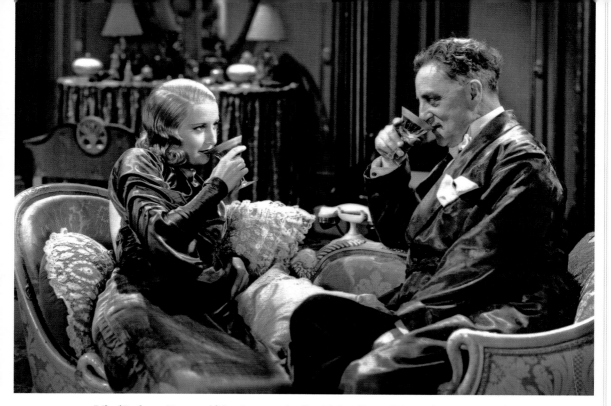

Lily (Barbara Stanwyck) having a cocktail with her Fuzzy Wuzzy (Henry Kolker).

Notable in all the sex and scheming, including the seduction of her lover's father, is Lily's ruthlessness. The film does not shy away from exposing predatory capitalist patriarchy and flips it on its head in order to show the character's ascent. Lily is a "fallen woman" who is a creation of the kind of callous men she preys upon. Censors were not happy, and scenes were cut at release. In fact, the fully restored version we are able to see today was not rediscovered until 2014.

Stanwyck gives an arresting performance that makes the unromantic romance that is *Baby Face* possible, proving herself to be the right actress to deliver a searing indictment of the 1930s amoral financial landscape (it is no accident that the men Lily is sexually exploiting are bankers). Stanwyck plays one of the coldest, most scandalous characters of the era, loyal only to her Black compatriot, Chico, a camaraderie that pushed boundaries, even for a pre-code film.

FUZZY WUZZY

When things do not work out with a lover, Lily preys on his father, the first vice president of Gotham Trust, J. P. Carter (Henry Kolker). In conversation, she calls J. P. by his pet name, Fuzzy Wuzzy. This clearly softens him because when she asks cutely for money, he replies, "My dear, ask me something difficult." Get splendidly fuzzy wuzzy with this mix so delicious it will coax most anyone into doing anything.

2 ounces white rum
½ ounce elderflower liqueur
½ ounce fresh lemon juice
2 drops orange blossom water
1 egg white

Shake rum, elderflower liqueur, lemon juice, orange blossom water, and egg white vigorously with ice. Strain into a cocktail glass.

"A woman, young, beautiful like you, can get anything she wants in the world. Because you have power over men! But you must use men! Not let them use you. You must be a master! Not a slave."

—ADOLF CRAGG
(ALPHONSE ETHIER)

MIDNIGHT MARY

"Midnight" Mary Martin (Loretta Young) calmly reads *Cosmopolitan* during her trial for killing her gangster lover Leo Darcy (Ricardo Cortez) before he could kill her other lover, Tom Mannering Jr. (Franchot Tone). She is barely paying attention to her own fate because she does not expect the trial to go well; given Mary's gender and class, things are already stacked against her. She knows this because, even though she is a good girl at heart, hers has been a life of poverty and crime. Tom, the son of a wealthy family, pulled her out of a brothel. She owed him and only killed to defend him—but the law does not care and here comes a death sentence.

Booze-soaked and violent, *Midnight Mary* (1933) would be just another morality play except that murder and divorce lead to a happy ending. Director William Wellman coaxes a smart and lean story by Anita Loos into movie magic, convincing us to be sympathetic to a character trapped by patriarchy. Life was hard for women in the 1930s, and *Midnight Mary* turns the lack of opportunity into a tale of redemption.

Wellman creates stylish mayhem in the film with some very long and passionate kisses, frank discussions of sex, and a pregnancy out of wedlock. But this is also a drinker's film, filled with wonderful vignettes out on the town and in speakeasies. Cocktails abound—watch for the great scene of Tom and Mary eating leftover turkey while downing champagne.

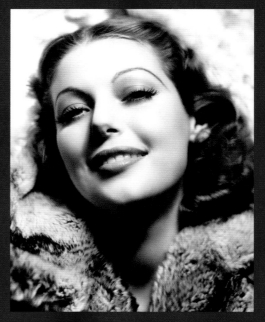

Radiant Loretta Young in furs.

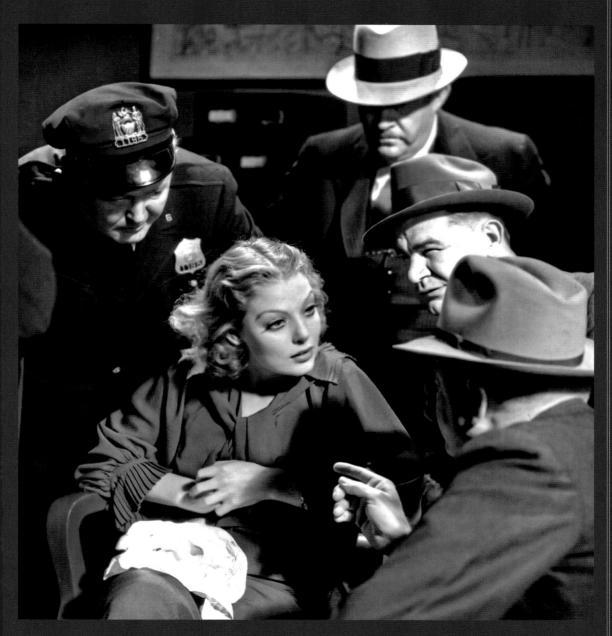

Mary (Loretta Young) gets herself in trouble.

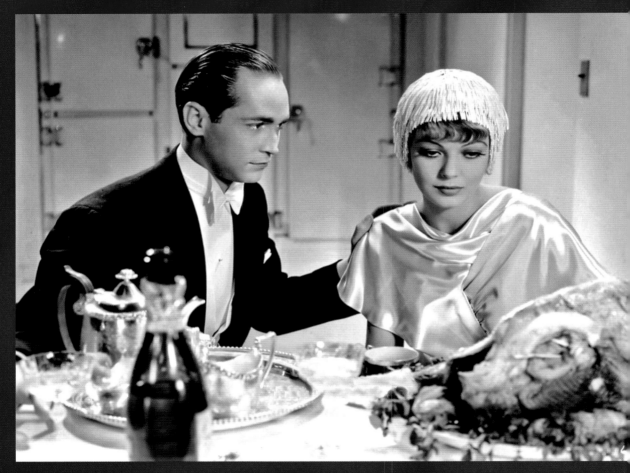

Franchot Tone and Loretta Young share a late-night snack.

Midnight Mary

A tequila Bloody Mary is a Bloody Maria, the addition of Clamato yields a Bloody Caesar, and there is a tomato-less version called a Bloodless Mary. But a Red Snapper? It is a Bloody Mary made with gin, and it predates the vodka version we know today. The Red Snapper is the inspiration for the Midnight Mary, a liquid murderess with a touch of glam.

2 ounces London Dry gin
2 ounces tomato juice
½ ounce fresh lemon juice
1 dash Tabasco sauce
1 ounce sparkling wine
Lemon wheel, for garnish

Shake gin, tomato juice, lemon juice, and Tabasco sauce with ice and strain into a highball glass with ice. Top with sparkling wine and garnish with a lemon wheel.

TOM MANNERING JR (FRANCHOT TONE):
*"Now, what do you suppose
made me think of sex?"*

MARY MARTIN (LORETTA YOUNG):
*"I can't imagine.
Most men never do."*

DINNER AT EIGHT

George Cukor's *Dinner at Eight* (1933) serves up one of the great all-star films of the pre-code era (another being the previous year's *Grand Hotel*). Based on a Broadway hit of the same name by Edna Ferber and George S. Kaufman, its setup is elegant in its simplicity; Millicent (Billie Burke) and Oliver Jordan (Lionel Barrymore) are throwing an extravagant dinner party for their wealthy acquaintances during the height of the Depression.

Brimming with interesting characters, intriguing sub-plots, and snappy dialogue, the film culminates in the much-anticipated meal. Producer David O. Selznick loaded the cast with popular actors all at various points in their real-world careers, making the movie a meta-commentary on status and fame. Vaudeville performer Marie Dressler plays a fading stage actress, and John Barrymore portrays a washed-up silent film star. These are contrasted with younger cast members, such as Jean Harlow, who, hot off her lauded role in *Red Dust* (see page 110), demonstrates her comedic chops. The juxtaposition between young and old stars intentionally highlights the generational upheaval caused by the swiftly changing social mores of the early 1930s. A beloved film, it is cynical, funny, and honest.

It is cocktail time with Grant Mitchell as Ed Loomis, Louise Closser Hale as Hattie Loomis, Jean Harlow as Kitty Packard, Wallace Beery as Dan Packard, Edmund Lowe as Dr. Wayne Talbot, Madge Evans as Paula Jordan, and Billie Burke as Millicent Jordan. ▶

"*I'm drunk, and I know I'm drunk, but I know what I'm talking about.*"

—LARRY RENAULT
(JOHN BARRYMORE)

THE
BERRY-MORE

The brothers Barrymore, along with sister Ethel, were the third generation of a legendary acting family from Philadelphia. The three siblings only appeared in one movie together, 1932's Rasputin and the Empress, *but the two brothers costarred in four other films, including* Night Flight *and* Grand Hotel. *This ode to the Barrymore family is based on a once-popular post-prandial concoction called café au kirsch. The three raspberries represent the siblings.*

1 ounce brandy
¾ ounce kirschwasser
¾ ounce raspberry syrup (see page 64)
¾ ounce espresso
1 egg white
3 raspberries, for garnish

Shake brandy, kirschwasser, raspberry syrup, espresso, and egg white vigorously with ice. Strain into a cocktail glass. Garnish with raspberries.

FOOTLIGHT PARADE

Cats! Former Broadway musical director Chester Kent (James Cagney) has turned into a prologue producer—prologues being live numbers that run before the main feature in movie theaters. He is hot on an idea that involves cats. To impress his business partners and a client, Kent and his company must rehearse and perform three new musical numbers.

Famous for gangster roles such as in *The Public Enemy* (see page 50), Cagney campaigned for the role of Chester Kent. A former vaudeville performer, Cagney demonstrates his singing and dancing chops in a twenty-minute spectacle topped with "Shanghai Lil," which opens with a drunk Kent looking for his prostitute girlfriend in an opium den. The third of choreographer Berkeley's standout

Kent has an idea involving cats.

James Cagney lobbied for the part of Chester Kent. Here he stands with four Busby Berkeley dancers.

musicals of 1933, *Footlight Parade* is most famous for "By a Waterfall," an extraordinary number featuring three hundred synchronized swimmers. Poking the eye of the authority, the film includes a censor character, a boob (played by Hugh Herbert) who has the job because of nepotism.

By turns silly, sexy, and smart, *Footlight Parade* features a cast at the top of their game; Cagney and Joan Blondell (playing Kent's assistant) make the show but are ably assisted by Ruby Keeler, Dick Powell, and Frank McHugh. The film was a smashing success at the time and remains one of the great musical spectacles. Be sure to look for the pre-code wink when Blondell calls her roommate Vivian Rich (Claire Dodd) a bitch. Meow.

HERE KITTY KITTY

All cats love cream, and even more so when it is crème de menthe and crème de cacao. Here is a dreamy, creamy combination that makes for a perfect film-watching companion. To get the most out of a mint leaf, slap it between the palms of your hands. It's like catnip for cocktailers.

1¼ ounces bourbon whiskey
1 ounce crème de cacao
¾ ounce crème de menthe
Mint leaf, for garnish

Shake whiskey, crème de cacao, and crème de menthe with ice and strain into a cocktail glass. Garnish with a mint leaf.

"I wouldn't beef about being locked up with the man I love!"

—NAN PRESCOTT (JOAN BLONDELL)

Dancers creating a human fountain for the number "By a Waterfall." ▶

FLYING DOWN TO RIO

F lying Down to Rio (1933) features scantily clad showgirls strapped to the wings of biplanes doing aerial stunts. If that does not pique curiosity, the film is also the first on-screen pairing of Fred Astaire and Ginger Rogers. Not yet stars, the two play supporting roles to Gene Raymond as band leader Roger Bond and Dolores del Río playing Brazilian beauty Belinha De Rezende. But the dance duo steals the show.

The movie features a nightgown-thin plot in support of an exotic locale (Rio), an exotic actress (del Río), and an exotic dance (the Carioca). When girl-crazy band leader

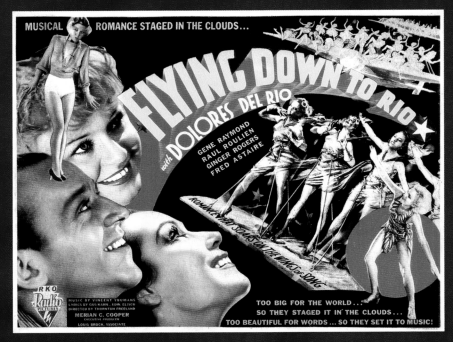

The film promises showgirls performing on airplanes.

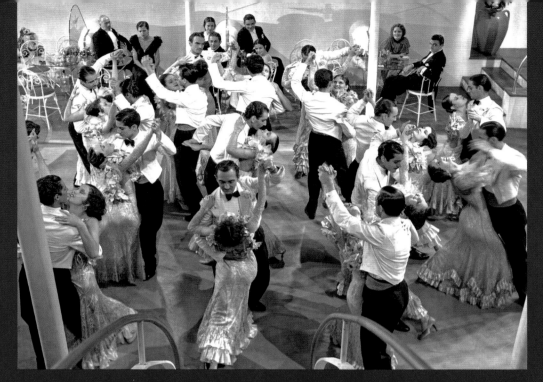

Couples enjoying cocktails while others dance.

Bond meets Belinha in Miami, he follows her to Brazil by securing an engagement at the Hotel Atlântico in Rio de Janeiro. As luck wouldn't have it, Belinha is already engaged to Bond's good friend Julio (Raul Roulien). But this is nothing a stop-over on a deserted island can't fix. The aforementioned aerial show is a hit and secures the financial future of his soon-to-be wife's hotel.

The story is an excuse for magical performances, like Roulien's "Orchids in the Moonlight" and Rogers's "Music Makes Me," which conveniently blames music for loss of sexual control. However, it is the Astaire-Rogers number "Carioca" that made audiences go wild for the film and launched the famed pair we know today. It is worth noting that the professional partnership of the two performers endeared the duo to audiences at the time. Sure, they can dance, but they also work together as equals. Astaire and Rogers would go on to make eight more films in the 1930s.

HOTEL HIBISCUS

The film opens at the Hotel Hibiscus in Miami, where Roger Bond and his Yankee Clipper Band are playing. Flavorful hibiscus flowers are used to make tea and can be found in grocery stores and online. Steeped with sugar, the flowers also make an excellent flavored syrup for cocktails. Have this refreshing mix in hand as the band strikes up a tune in the hotel's Date Grove.

2 ounces white rum
¾ ounce fresh lime juice
½ ounce hibiscus syrup
(see recipe below)
1 dash Angostura bitters
Lime wheel, for garnish

FOR THE HIBISCUS SYRUP

1 cup water
1 cup sugar
½ cup dried hibiscus petals

Shake rum, lime juice, hibiscus syrup, and bitters with ice and strain into a cocktail glass. Garnish with a lime wheel.

In a small saucepan over high heat, bring water to a boil. Remove from heat, add sugar and stir to combine. Add hibiscus and let steep for 15 minutes. Strain into a sealable jar. Hibiscus syrup will keep up to 2 weeks, sealed, in the refrigerator.

"What do these South Americans got below the equator that we don't?"

—BELINHA'S FRIEND (UNCREDITED)

QUEEN CHRISTINA

arbo burst onto the talkie scene in 1930's *Anna Christie* with the words, "Gimme a whiskey, ginger ale on the side. And don't be stingy, baby." Her portrayal of a brooding, working-class woman made the film the highest-grossing feature of the year, and it set the tone for hard-edged, down-to-earth pre-code women. As perhaps the biggest star of the age, Garbo was a sensation on the order of the Beatles or Elvis, and other actresses followed in her wake.

In Rouben Mamoulian's *Queen Christina* (1933), Garbo plays a Swedish princess as a liberated, cross-dressing modern woman. This was old news for Garbo, who had already introduced pants to women's apparel when she appeared wearing her lover's clothes in 1929's *The Single Standard*. By 1933, it was not just fashion that she was liberating but sexuality as well; the

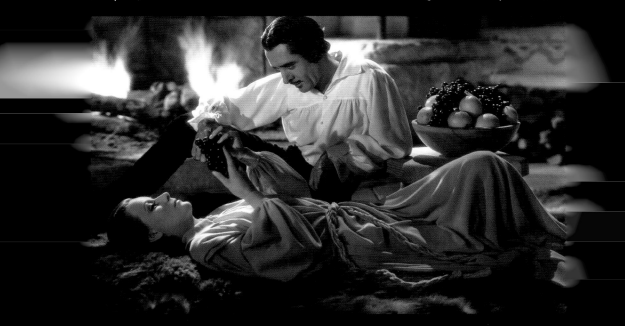

Garbo and John Gilbert quickly go from fruit to forbidden fruit.

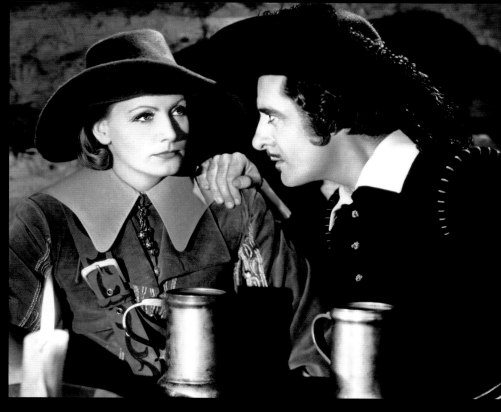

Garbo disguised as a man enjoying a drink in a bar.

film features not only extramarital sex but includes an undeniable lesbian subtext. Look for the scene where Garbo proclaims she is going to "die a bachelor" while she is wearing men's clothes.

Queen Christina has come of age but eschews marriage out of devotion to her country. One night she slips away (dressed as a man, naturally) and finds herself at an inn sharing a room with Spanish envoy Antonio (John Gilbert). He is traveling to see the queen on behalf of his king. While Christina reveals she is a woman, she does not share that she is the queen, and the two sleep together. When the inn is snow-bound, the blissful tryst lasts a few days.

Back at court, after Antonio discovers her identity, Christina takes him as her lover to the disappointment of her counselors (and a former lover). The romance ends tragically, but also triumphantly for this bisexual, cross-dressing heroine who remains elegant and selfless to the end. Sophisticated and smart, Mamoulian's film is an ode to the most unorthodox and independent of film stars.

"It's all a question of climate. You cannot serenade a woman in a snowstorm. All the graces in the art of love, the elaborate approaches that will make the game amusing, can only be practiced in those countries that quiver in the heat of the sun."

—ANTONIO (JOHN GILBERT)

SERENADE IN A SNOWSTORM

"You can't serenade a woman in a snowstorm," says Antonio, although he seems to do a pretty good job wooing Queen Christina anyway. This cocktail is a romantic engagement between Swedish and Spanish elements, aquavit and sherry. The two work well together, the caraway from the aquavit melding with the fruitiness and nuttiness of the sherry. It just might be a love match.

1½ ounces aquavit
1½ ounces manzanilla sherry
¼ ounce Luxardo maraschino liqueur
1 dash Angostura bitters
Orange peel, for garnish

Stir aquavit, sherry, maraschino liqueur, and bitters with ice. Strain into a rocks glass with a large ice cube and garnish with an orange peel.

◀ As the marquee of the Astor Theatre makes clear, Garbo was queen.

DESIGN FOR LIVING

In a loose adaptation of a scandalous Noel Coward play, three young adults decide that a ménage à trois is their ideal arrangement in director Ernst Lubitsch's racy *Design for Living* (1933). Living carefree in Paris, painter George Curtis (Gary Cooper) and playwright Tom Chambers (Fredric March) meet radiant and mischievous illustrator Gilda (Miriam Hopkins) on a train. Even though she is being pursued, and likely supported, by businessman Max Plunkett (Edward Everett Horton), Gilda moves in with the starving artists and falls in love—with both of them.

When George and Tom discover that Gilda has been two-timing them, the three form a "gentlemen's agreement." It is a very frank cinematic moment when they decide their situation will work only if there is "no sex." Of course, things bubble over between Gilda and George when Tom goes away to London. Then Gilda sleeps with Tom when he returns. By now, only Plunkett has not received Gilda's favors, and she marries him on the rebound from George and Tom. By the end of the film, Hopkins has left her husband, and the love triangle is happily reunited in a cab together while the three smirkingly renew their "no sex" vows.

Design for Living may be subdued compared to more explicit movies of the time,

> *"Immorality may be fun, but it isn't fun enough to take the place of 100 percent virtue and three square meals a day."*
>
> —MAX PLUNKETT
> (EDWARD EVERETT HORTON)

but it explodes convention; three young people are shown living sexually and financially carefree lives during the Depression, and they do not give a damn about conventional things like marriage. What's more, the successful businessman (and husband) Plunkett, who represents traditional American values, is the butt of all the jokes. It's enough that some historians cite this as the most subversive pre-code film.

A painter and a playwright meet a mischievous illustrator on a train. ▶

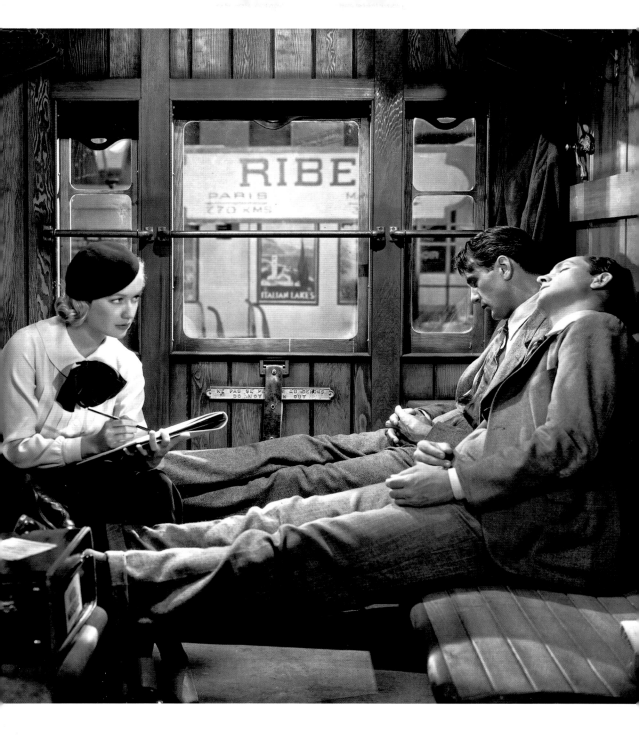

Three young people decide a threesome is the best arrangement.

LOVE TRIANGLE

The love triangle was one of director Ernst Lubitsch's favorite setups, and they develop in a number of his films. The famous three-part cocktail of the 1930s was the sidecar, and its namesake vehicle also neatly fits three passengers. In keeping with the classic triangular recipe, this racy drink is equal parts.

1 ounce bourbon whiskey
1 ounce apricot liqueur
1 ounce fresh lemon juice
Lemon wheel, for garnish

Shake whiskey, apricot liqueur, and lemon juice with ice. Strain into a cocktail glass and garnish with a lemon wheel.

SEARCH FOR BEAUTY

Inspired by the financial success of the 1932 L.A. Olympic games, cons Larry Williams (Robert Armstrong) and Jean Strange (Gertrude Michael) conspire with publisher Dan Healy (James Gleason) to buy the bankrupt magazine *Health & Beauty* and turn it into a moneymaking "skin" rag. To get past censors and put a legitimate spin on the enterprise, they enlist Olympian Don Jackson (Buster Crabbe, a real-life 1932 Gold Medal winner) and Barbara Hilton (Ida Lupino, making her American debut at sixteen). Then the cons launch a "health farm" that will actually be a brothel where rich Hollywood types can meet young, ahem, fitness talent.

If this sounds like an ideal setup for a lot of hijinks and uncovered skin, it is. The film sports plenty of YMCA-military-style group exercises as well as locker room scenes of male nudity. In one scene there are at least four men showering naked, likely a pre-code record. Never mind that Barbara's underage cousin—or, in this case, more underage cousin—Sally (Toby Wing) is caught table-dancing erotically at a party. Not to worry, she is saved from elderly lechers by Barbara filling in for her. Everyone is objectified in this romp dedicated to bulging muscles and bouncing flesh. There is even a climactic Busby Berkeley–inspired number that features dancers in tight gym outfits suggestively raising flagpoles together.

> *"There's nothing wrong with sex, Dr. Rankin, as long as it leads to ... uh ... what it leads to."*
>
> —LARRY WILLIAMS (ROBERT ARMSTRONG)

Likely the wildest thing about *Search for Beauty* (1934)—other than the fact that it was ever made—is that the film spoofs predators exploiting young actors for sex and profit while itself being such an exploitation. Welcome to pre-code satire. Please remember to lift your jaw off the floor.

Ida Lupino was just sixteen in her debut. She went on to star in classics such as *High Sierra*. ▸

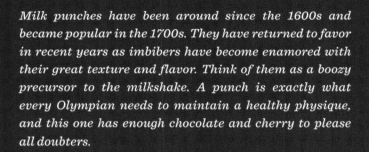

Milk punches have been around since the 1600s and became popular in the 1700s. They have returned to favor in recent years as imbibers have become enamored with their great texture and flavor. Think of them as a boozy precursor to the milkshake. A punch is exactly what every Olympian needs to maintain a healthy physique, and this one has enough chocolate and cherry to please all doubters.

2 ounces bourbon whiskey
3 ounces whole milk
½ ounce crème de cacao
½ ounce Luxardo maraschino liqueur
1 dash Angostura bitters
Freshly grated nutmeg, for garnish

Shake whiskey, milk, crème de cacao, maraschino liqueur, and bitters vigorously with ice. Strain into a rocks glass and garnish with nutmeg.

MANDALAY

Marjorie Lang, known as Spot White—real name Tanya Borodoff (Kay Francis)—is traveling by riverboat to Mandalay, Burma. She was abandoned in Rangoon by her lover, Tony Evans (Ricardo Cortez), and forced to become a "hostess" in a brothel run by gangster Nick (Warner Oland). When authorities close in on the business (and her), she extort the police comm Owen) and books passa boat to find an anonymo

The trouble is, ex-lov on the boat and tries to f with him to be a "hostes brothel. But Marjorie is S ger, and the once-naive g trol of her life. She is a fr become as clever in her radiant in her evening go

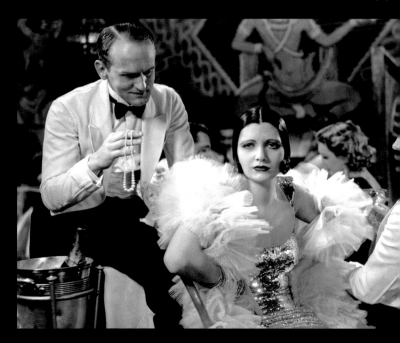

Tanya Borodoff (Kay Francis) is forced by Tony Evans (Ricardo Cortez) to be a "hostess" in Nick's (Warner Oland) b

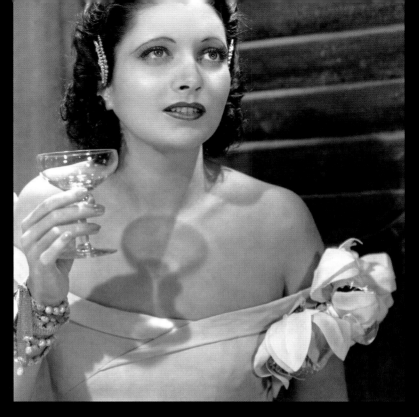

Tanya (Kay Francis) transformed into Spot White.

Michael Curtiz's *Mandalay* (1934) is ostensibly a film about redemption and self-determination, but along the way it becomes one of the darkest of all pre-code tales. Spot White, when confronted with the prospect of returning to sexual servitude, and sensing an opportunity, simply behaves practically—spoiler: she murders Tony and gets away with it.

Ultimately, White is punished for crime, or, rather, she punishes herself going on a suicide mission to assist with outbreak of a deadly fever. It is a poign sacrificial ending, one that Curtiz wo later famously employ in *Casablanca*.

JARDIN D'ORIENT

hen Tony takes Marjorie out on the town, their
rriage passes under a sign that reads "Jardin
Orient." They arrive at Nick's, the "best supper
ace in Rangoon." The spot, full of fancy clientele
suits and gowns—plus dancing girls for sale—
ll change Marjorie's fate forever. Cinnamon
native to Burma and brings luxurious spice to
is plush champagne cocktail.

1 ounce white rum
½ ounce cinnamon syrup
(see page 141)
1 bar spoon Cointreau
4 ounces sparkling wine

In a champagne flute, combine rum,
cinnamon syrup, and Cointreau. Top with
sparkling wine.

Spot White (Kay Francis) needs a top-up. ▶

SPOT WHITE (KAY FRANCIS):
*"Haven't we met
before, Colonel?"*

COLONEL THOMAS DAWSON
(REGINALD OWEN):
*"No, this is my first
look at you."*

SPOT WHITE:
"Is it overwhelming you?

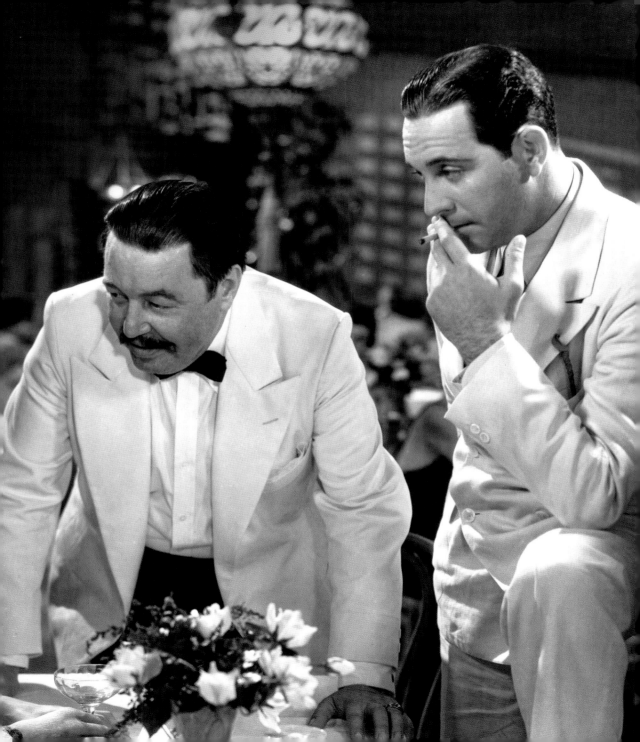

IT HAPPENED ONE NIGHT

One of the most famed and beloved of all pre-code movies, director Frank Capra's *It Happened One Night* (1934) won every Academy Award for which it was nominated and is the first of three movies in history to win the "Big Five." The film is a masterpiece, crackling with wit and positively oozing charm.

> *"Remember me?*
> *I'm the fellow you*
> *slept on last night."*
>
> —PETER WARNE
> (CLARK GABLE)

Spoiled heiress Ellen "Ellie" Andrews (Claudette Colbert) has married scheming cad King Westley (Jameson Thomas) against the wishes of her father (Walter Connolly), so her father has whisked her away on his yacht. Ellie escapes and finds herself penniless—as well as mostly useless in the real world—as she makes her way to New York City to be reunited with her beau. Along the way, she falls in with rapscallion reporter Peter Warne (Clark Gable) who offers to help reunite her with her husband in exchange for an exclusive story. Not to spoil things, but despite initial animosity, they fall for each other.

Adventure story, buddy flick, romance, and comedy all in one, Capra manages to weave several Depression-era subplots together to reveal the main characters' worldviews. In fact, the film consistently addresses the country's yawning class divide. Everything Ellie and Peter argue about is a result of their social stations, and by the end each has shared and revised their class perspectives. Of particular note is spoiled Ellie's relationship to food. When we meet her, she is on a hunger strike because her father is keeping her from Westley. She even refuses a piece of steak—unthinkable in hungry 1934 America. However, after a few days on the road with Peter, Ellie learns to relish dunking a doughnut in black coffee.

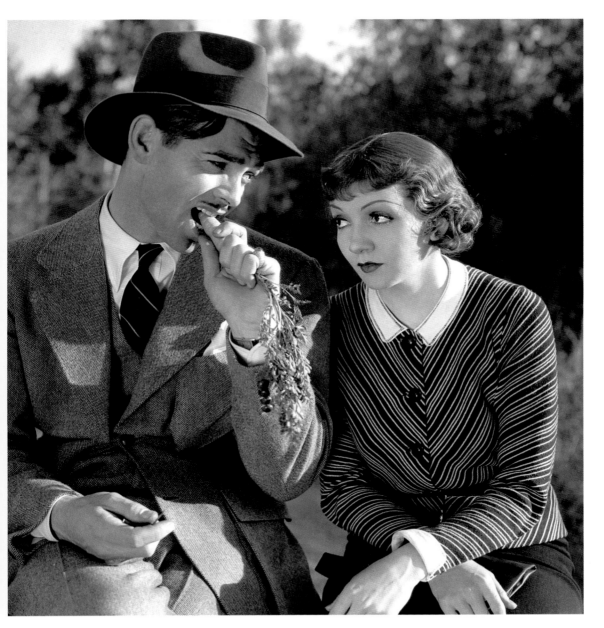
Hunger on the road means eating carrots.

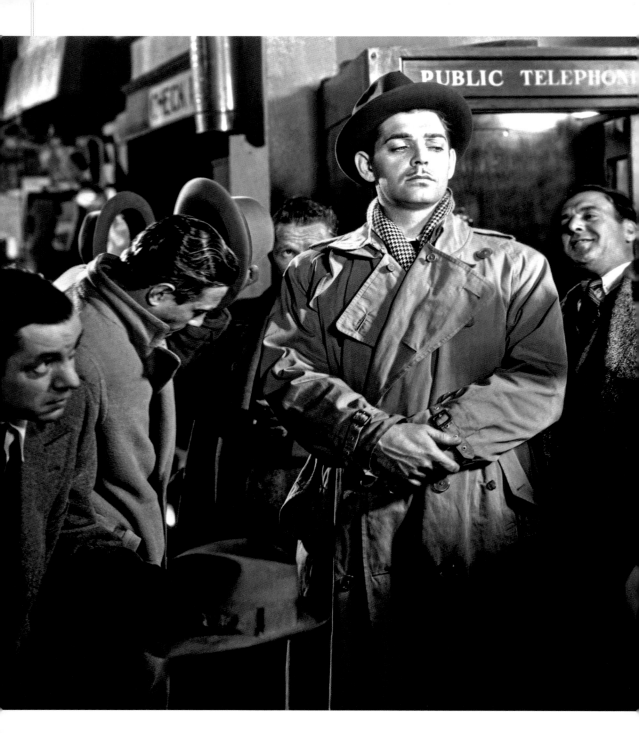

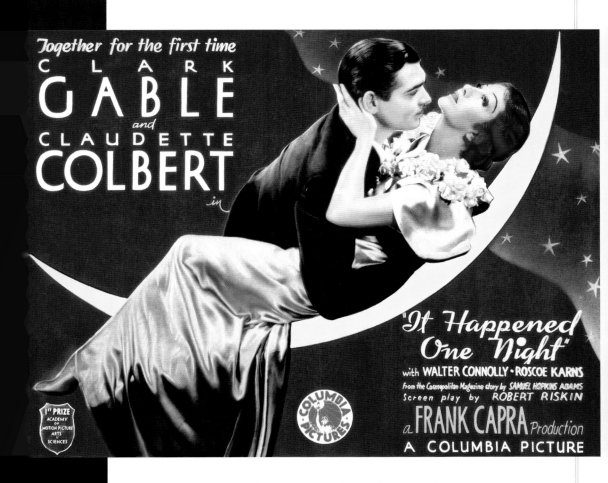

Together for the first time
C L A R K
GABLE
and
CLAUDETTE
COLBERT
in

1ST PRIZE
ACADEMY
OF
MOTION PICTURE
ARTS &
SCIENCES

COLUMBIA
PICTURES

'It Happened
One Night'
with WALTER CONNOLLY · ROSCOE KARNS
From the Cosmopolitan Magazine story by SAMUEL HOPKINS ADAMS
Screen play by ROBERT RISKIN
a FRANK CAPRA Production
A COLUMBIA PICTURE

▲ The first film to win the "Big Five" at the Academy Awards.

◀ Clark Gable plays rapscallion reporter Peter Warne.

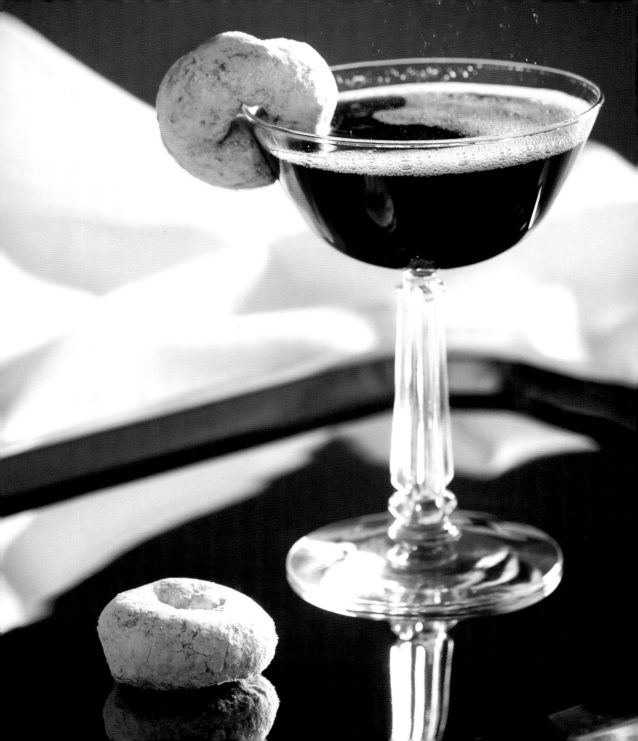

IT HAPPENED ONE MORNING

Dunking a doughnut in coffee is an important transformation in the film, indicating the moment when Ellie learns to enjoy the simple things in life. Re-create the scene with this coffee cocktail that is certain to wake you up on the right side of the bed. Add a fresh doughnut garnish, and it is a little bit of heaven.

1½ ounces rye whiskey

1 ounce Kahlua

¾ ounce espresso

¼ ounce honey syrup
(see page 25)

Doughnut, for garnish

Shake whiskey, Kahlua, espresso, and honey syrup with ice. Strain into a cocktail glass and garnish with a doughnut.

TARZAN AND HIS MATE

Let's get this safari started. A follow-up to 1932's successful *Tarzan the Ape Man*, *Tarzan and His Mate* (1934) ups the ante with a more suggestive title and even fewer clothes on lithe Jane. Tarzan (Olympic swimmer Johnny Weissmuller) and Jane Parker (Maureen O'Sullivan) now live happily—out of wedlock—in the jungles of Africa with their pet chimpanzee, Cheeta. Harry Holt (Neil Hamilton) has returned with business partner Martin Arlington (Paul Cavanagh) for ivory, but also to coax Jane to return to civilization. In fact, they bring her a tent full of elegant gowns to tempt her. Loyal Jane demurs and stays with her primitive man (and in her jungle G-string).

The loads of flesh on display got the censors' attention, the most egregious instance being nude swimming (courtesy of body double Olympian Josephine McKim). In the famed scene, Tarzan tosses Jane from a tree and what little clothes she

> *"You know, you're the first woman I ever had to coax into an evening gown."*
>
> —MARTIN ARLINGTON (PAUL CAVANAGH)

has on are torn off. In no hurry to get out of the refreshing pool, she goes for one of the longer skinny-dips on film. This swim is often cited as an example of why the code was enforced a few months later, in July 1934.

Despite increased censorship, the Tarzan franchise continued to be an enormous success; Maureen O'Sullivan played Jane in a couple more films, and Johnny Weissmuller played his character again ten times, until 1948.

Jane, played by Maureen O'Sullivan, wears less than ever in this sequel. ▶

Tarzan carries his "mate"; even the film's title bothered the censors.

TARZAN'S MATE

*This tropical cocktail is optimal for watching Tarzan and Jane romp through th
jungle. It features rum, which was a popular Prohibition spirit because it was eas
to smuggle into US ports from the Caribbean. It pairs here with pineapple juice an
lime, with the addition of vanilla to round out the appeal.*

2 ounces rum
1 ounce pineapple juice
½ ounce fresh lime juice
¼ ounce vanilla syrup
(see page 61)
1 dash Angostura bitters
Lime wheel, for garnish

Shake rum, pineapple juice, lime juice, vanilla syrup, and
bitters with ice and strain into a rocks glass with ice.
Garnish with a lime wheel.

MURDER AT THE VANITIES

Released just six weeks before the code went into effect, *Murder at the Vanities* (1934) features half-naked chorus girls, topless chorus girls popping up from marijuana leaves, and chorus girls covered in blood. There is also a song dedicated to marijuana, a song about the end of Prohibition, and Duke Ellington with his orchestra by way of a grand finale.

Jack Ellery (Jack Oakie) is trying to put on a lavish show when someone attempts to murder one of his stars, Ann Ware (Kitty Carlisle). Police Lieutenant Bill Murdock (Victor McLaglen) arrives on the set but is less interested in the case than the ladies, and before long another star, Rita Ross (Gertrude Michael), and private investigator Sadie Evans (Gail Patrick), are also murdered. High-energy and demented, the hilarious mess of a film was a disappointment at the box office. However, it is an unmissable pre-code spectacle.

As if deliberately flaunting forbidden content, *Murder at the Vanities* is awash in bawdy dialogue, murder, and boundary-pushing scenes that seem to test just how much flesh and lewdness could be put on-screen. Turns out a lot—that is, until two months later when the code was enforced. But before the era came to an end, this murder mystery–meets–backstage musical offered an unrestrained, harebrained hoot that culminates in hot jazz.

Chorus girls are in trouble in this behind-the-scenes whodunit.

"*Them babies look like they got clues or something.*"

—BILL MURDOCK (VICTOR McLAGLEN)

COCKTAIL FOR TWO

— MAKES 2 —

It is a rare moment when cocktails are the subject of a show tune as they are in "Cocktails for Two," performed by Carl Brisson. So if you find yourself "in some secluded rendezvous / That overlooks the avenue / With someone sharing a delightful chat / Of this and that / And cocktails for two"—this two-serving delight is exactly the right mix.

2 ounces London Dry gin

2 ounces dry vermouth

1 ounce apricot liqueur

¾ ounce honey syrup (see page 25)

Stir gin, dry vermouth, apricot liqueur, and honey syrup with ice and strain into two cocktail glasses.

◀ Chorus girls in swimsuits, furs, and top hats.

THE THIN MAN

Prohibition, the so-called Noble Experiment, ended on December 5, 1933. *The Thin Man*, often hailed as the greatest of all cocktail-centric movies, released the following spring. The film features tipsy Nick Charles (William Powell) and his wife, Nora (Myrna Loy), a lovable couple who spend their days engaging in witty banter while sipping fancy drinks—when not chugging directly from the bottle. Written by noir maestro Dashiell Hammett of *Maltese Falcon* fame, *The Thin Man* is lighter than his normal fare and one of cinema's most playful mysteries, thanks to the adaptation by husband-and-wife team Frances Goodrich and Albert Hackett.

> *"The important thing is the rhythm. Always have rhythm in your shaking. Now, a Manhattan you shake to foxtrot time, a Bronx to two-step time, but a dry martini you always shake to waltz time."*

—NICK CHARLES (WILLIAM POWELL)

Nick Charles is a retired private detective who has grown accustomed to a life of luxury, thanks to his wealthy wife, Nora, a high-society heiress. Inventor Clyde Wynant

William Powell proposes a toast at his holiday party. ▶

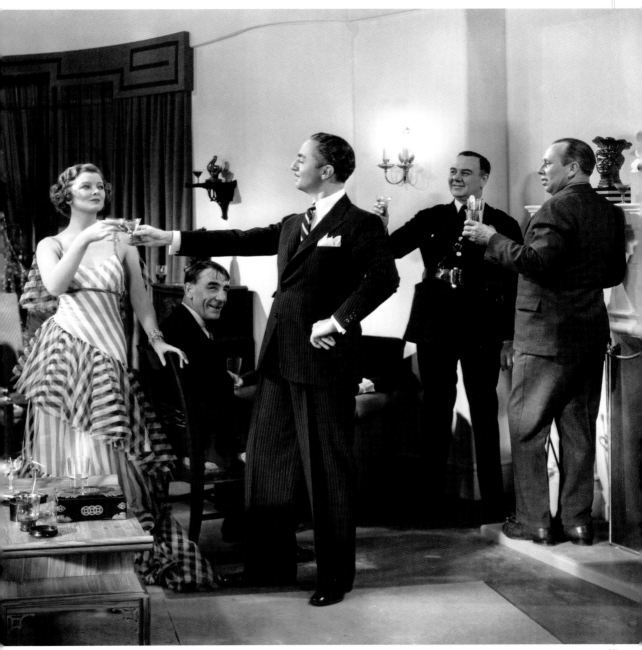

(Edward Ellis) disappears and is a prime suspect in the murder of his mistress, Julia (Natalie Moorhead). Wynant's daughter, Dorothy (Maureen O'Sullivan), tries to enlist Nick to investigate, but he is reluctant to get involved, even though Nora craves some vicarious excitement. Charles relents when he realizes Police Lieutenant John Guild (Nat Pendleton) is coming to all the wrong conclusions. In order to resolve the case, Nick decides the best course of action is to invite all the suspects for dinner, making for a delightful grand finale.

A fast-paced romantic comedy brimming with chilled drinks and crackling dialogue, *The Thin Man* enamored audiences at the time, and the team of Powell and Loy went on to make five more *Thin Man* films together. What really hooked

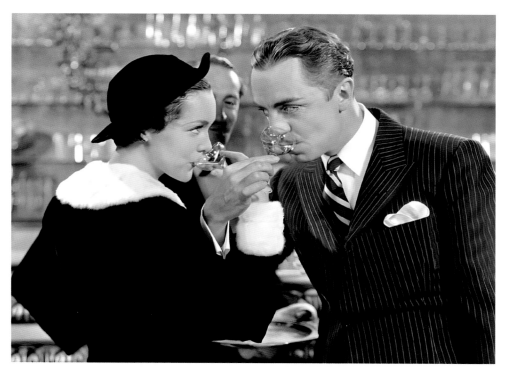

Maureen O'Sullivan as Dorothy and William Powell as Nick show off their cocktail-drinking skills.

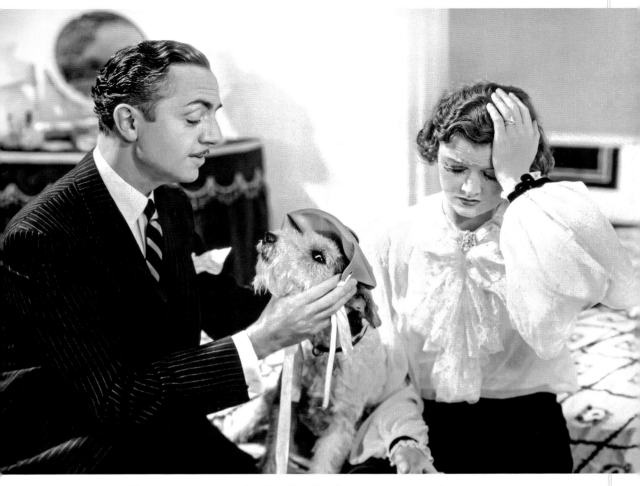

There are so many cocktails in the film that even Asta gets a hangover.

audiences was the astonishing rapport between Nick and Nora; their marriage works, and the two wisecrackers are true partners. Maybe cocktails are the secret to marital bliss, after all. The films were so popular, there is a style of cocktail glass named after the intrepid duo, the Nick & Nora (see page 233).

ASTA

With all the drinking in The Thin Man, *a little hair of the dog will be necessary. This cocktail honors the Charleses' wire fox terrier, Asta. The famous pooch (his real name was Skippy) appeared in* The Thin Man *series but also in* The Awful Truth *(1937) and* Bringing Up Baby *(1938). The expression "hair of the dog" comes from a time when hair from a rabid dog applied to a wound was thought to cure its bite. While a hangover chaser can be pretty much anything, several period remedies include fresh ingredients such as lemon juice to revive the senses. Note that this cocktail is also perfect for holiday parties.*

Absinthe, to rinse
1 ounce white rum
½ ounce Cointreau
½ ounce dry vermouth
¾ ounce fresh lemon juice
¼ ounce vanilla syrup (see page 61)

Rinse a Nick & Nora or cocktail glass with absinthe. Shake rum, Cointreau, dry vermouth, lemon juice, and vanilla syrup with ice and strain into the prepared glass.

Cocktail Cherries

Maraschino cherries are called for in this book. There are a few brands that make decent versions (without all the dye and sugar) and are worth seeking out. In most cocktail bars, Amarena cherries have supplanted fake red-dye cocktail cherries over the past number of years. They are also worth having on hand for classics such as Manhattans.

Club Soda

Carbonated water, seltzer, and club soda are not as interchangeable as one might think. Club soda includes additives such as sodium and potassium that lend additional flavor to drinks.

Eggs

Fear not the raw egg; it makes for incredible texture in mixed drinks. To prevent shells from getting into your drink, always crack on a counter surface and not on the edge of a glass. If you have a compromised immune system, consider powdered egg whites as an alternative; 2 teaspoons of powder to 1 ounce of water will yield a single white.

Grenadine

Although there are now a few good brands on store shelves, commercial grenadine is typically too sweet and contains red dye. Making it fresh is preferable and easy. Grenadine is useful in many classic cocktails and tropical drinks. Because it appears in a number of 1930s drinks, it is often employed in this book.

1 cup (8 ounces) pomegranate juice
1 cup Demerara sugar (or Turbinado or light-brown sugar)
½ ounce fresh lime juice
3 drops orange blossom water

In a small saucepan over medium-low heat, combine the pomegranate juice and sugar. Stir until the sugar dissolves, 3 to 4 minutes. Do not let the mixture boil as it will lose its freshness. Remove the pan from the heat, let cool, and add lime juice and orange blossom water. Allow mixture to cool before use, then transfer to a clean jar, seal, and keep refrigerated for up to 2 weeks.

TOOLS

Crafting cocktails does not require a lot of fancy or expensive equipment, but below are a few items that will make your drink-mixing easier and improve quality.

Jigger

Measuring is a must for quality drinks. There are several options available on the market, and the OXO jigger is ideal for most home bartenders.

Boston Shaker

The classic three-part shaker, often called a martini shaker, is not good for making most cocktails. They're often too small and the lid can get stuck when the ice cools the metal. The two-part Boston shaker is preferred. Originally composed of a metal tin and a pint glass, today the two parts are both metal for safety. Two-part metal shakers are widely available in kitchen stores and online.

Mixing Glass

Mixing glasses are used for all stirred drinks. They are necessary for making stirred drinks correctly, but any vessel will work in a pinch.

Bar spoon

A bar spoon is necessary to properly stir cocktails. One with enough heft at the end of the handle to crack ice is best, and they are widely available in kitchen stores and online.

Strainers

There are two styles of cocktail strainers: Hawthorne and julep. Hawthorne strainers are used for shaken drinks, while julep strainers are employed for stirred cocktails. If you are in doubt, buy a Hawthorne, which works just fine for both purposes.

Citrus Press

Hand-juicers are great for small amounts, but it is good to have a larger juicer with a reservoir. It may be worth investing in a quality juicer if you are making a lot of drinks for your cocktail parties. Citrus juice will keep overnight, but not any longer.

Y-peeler

A Y-peeler, sometimes called a Swiss peeler, is the perfect tool for citrus skin.

Muddler

A muddler should be made of non-stained, non-reactive wood. Avoid paint, plastic, and metal.

Lewis Bag and Mallet

Using a canvas bag with a heavy wooden mallet is the perfect way to get crisp (as opposed to wet) crushed ice fast. Available in stores and online.

Glassware

No special glassware is required to enjoy a good cocktail. However, a nice glass can help presentation and likely even boost flavor. If you do acquire cocktail-specific glasses, your first choice will likely be to invest in a set of coupe glasses—sometimes called champagne glasses—which are now widely available online. The best size for these is between 4 and 6 ounces. Additionally, good highball and rocks glasses can be helpful. Because they are called for in this book (they appear in 1930s films), Nick & Nora glasses would also make a fine investment. Sometimes called "small martini" glasses, Nick & Noras have a petite egg-cup-shaped bowl and an elegant stem.

Other Useful Items

Cutting board, paring knife, bottle opener, wine key, squeeze bottles (for citrus juices and syrups), microplane, funnel, large-format ice-cube trays, ice bucket, ice scoop, hand towels, cocktail picks

A FEW PRE-CODE-ERA COCKTAILS

Below are some of my favorite classic cocktails from the pre-code era.

Fine & Dandy

1½ ounces London Dry gin
¾ ounce Cointreau
½ ounce fresh lemon juice
1 dash Angostura bitters
Cherry, for garnish

Shake with ice and strain into a cocktail glass. Garnish with a cherry.

Silk Stockings

1½ ounces blanco tequila
1 ounce crème de cacao
1½ ounces cream
1 bar spoon grenadine
1 dash ground cinnamon

Shake with ice and strain into a cocktail glass. Garnish with the cinnamon.

Charlie Chaplin

1 ounce sloe gin
1 ounce apricot brandy
1 ounce fresh lemon juice

Shake with ice and strain into a Nick & Nora glass.

Depth Bomb

1 ounce applejack
1 ounce brandy
1 bar spoon fresh lemon juice
1 bar spoon grenadine

Shake with ice and strain into a rocks glass.

Mary Pickford

1 ounce white rum
1 ounce pineapple juice
¼ ounce grenadine
¼ ounce Luxardo maraschino liqueur

Shake with ice and strain into a cocktail glass.

Fallen Angel

1½ ounces London Dry gin
1 ounce fresh lime juice
½ ounce Cointreau

Shake with ice and strain into a cocktail glass.

Rolls Royce

1½ ounces London Dry gin
½ ounce dry vermouth
½ ounce sweet vermouth
¼ ounce Bénédictine

Stir with ice and strain into a
cocktail glass.

September Morn

2 ounces white rum
½ ounce fresh lime juice
¼ ounce grenadine
1 egg white

Shake with ice and strain into a
cocktail glass.

Journalist

1½ ounces gin
¾ ounce dry vermouth
¾ ounce sweet vermouth
1 bar spoon Cointreau
1 bar spoon fresh lemon juice

Shake with ice and strain into a
cocktail glass.

White Lady

2 ounces London Dry gin
½ ounce Cointreau
½ ounce fresh lemon juice
1 egg white

Shake with ice and strain into a
cocktail glass.

Joan Blondell

1 ounce gin
1 ounce dry vermouth
1 ounce Bénédictine
3 drops absinthe
1 dash Angostura bitters

Stir with ice and strain into a
cocktail glass.

Jack Rose

2 ounces applejack
1 ounce fresh lemon juice
½ ounce grenadine
Lemon peel, for garnish

Shake with ice and strain into a
cocktail glass. Garnish with a lemon peel.

French 75

1 ounce London Dry gin
1 ounce fresh lemon juice
½ ounce simple syrup
4 ounces sparkling wine

Shake gin, lemon juice, and simple syrup
with ice. Strain into a champagne flute
and top with sparkling wine.

Mah Jongg

2 ounces white rum
½ ounce London Dry gin
½ ounce Cointreau

Stir with ice and strain into a cocktail glass.

ACKNOWLEDGMENTS

A huge debt of gratitude is owed to my editor Cindy Sipala at Running Press/Hachette for her ongoing support and friendship over the years. This is our eighth book together and each one has been a pleasure. Likewise, a big thank-you goes to my sage agent, Clare Pelino. In addition, thanks go to production editor Cisca Schreefel, copy editor Martha Whitt, proofreaders Carrie Wicks and Lori Hobkirk, and indexer Jen Burton.

Mark A. Vieira, author of *Forbidden Hollywood*, provided information regarding pre-code films, which proved invaluable to me, and I offer a heartfelt thank-you for his generous help. I also thank him for his excellent fixes and suggestions on a draft of this manuscript.

I owe thanks to Turner Classic Movies for the opportunity to work with this material; I particularly want to thank John Malahy, Heather Margolis, Eileen Flanagan, Aaron Spiegeland, Pola Changnon, Genevieve McGillicuddy, Taryn Jacobs, and Marci Sacco.

Lastly, but truly firstly, a giant thank-you is owed to my wisecracking partner in film-watching and in life, Janine Hawley.

INDEX